# The Street is My Studio:
# East Harlem Protestant Parish

JOSEPH WOOD PAPIN

Edited by Jennifer Papin Maxwell

Copyright © 2017 Joseph Wood Papin

All rights reserved.

ISBN: 1545367272
ISBN-13: 978-1545367278

# DEDICATION

For Jane

## CONTENTS

| | | |
|---|---|---|
| | Acknowledgments | i |
| 1 | East Harlem Protestant Parish | 1 |
| | About the Author | 69 |

## ACKNOWLEDGMENTS

Without the combined efforts of my mother, Jane Papin,
my siblings: Janine, Julianne, Jonathan and Jessica,
and my husband, David Maxwell,
this book would not be possible.

In the process of sorting through the thousands of drawings that my father produced in his lifetime,
we came upon a collection of my father's handwritten and typed notes for an article that he wrote,
"The Street is My Studio," published in February 1959 in *American Artist* Vol. 23 No. 2 Issue 222.
The text on the East Harlem Protestant Parish is taken from the notes for that article.
I transcribed the notes while David photographed all the drawings
for inclusion in this book and companion volumes.

I am grateful to all of you for your help in bringing this book to fruition.

Jennifer Papin Maxwell, Ph.D.

Illustrations and text by

JOSEPH WOOD PAPIN

1958 - 1963

# EAST HARLEM PROTESTANT PARISH

By Joseph W. Papin, written circa 1958

I have always felt that individuals should not be judged according to their personal circumstances or environment, which might be poor or rich, but rather by their individual worth. It was in this light that I have attempted to record the scenes of New York, the Bowery, the Lower East Side, and most recently, East Harlem. I should like to sketch in briefly the scenes I encountered there and of some of the people who work daily with all of its problems.

East Harlem is one of the world's most densely populated areas, the most overcrowded section of this city, where 300,000 people live jammed together in little over one square mile. Many of my drawings were done on East 100$^{th}$ Street between 1$^{st}$ and 2$^{nd}$ Avenue where 4,000 people are packed into 27 rotting tenements. The people, mostly Puerto Ricans and Negroes just up from the south, struggle for survival in an atmosphere tense with hatred, fear, and discrimination. They are the latest in the waves of immigrants who have settled here in the past 60 years. They are isolated by race, religion, language and culture. They must compete for both homes and jobs. I found the whole spectrum of social problems here: poor health conditions, family breakdown, delinquency. The strong maintain the struggle; the weak succumb to apathy and despair.

Yet even in the face of odds such as these, though most of the city finds itself too busy or indifferent to care, I found a group of young ministers and students of the East Harlem Protestant Parish (established in 1948) who, with their wives, were living here and working with quiet efficiency to help on every level they could. Here was something really unique in my experiences with churches. These men do not use their "concern" to attract people to some phase of religious life, nor do they demand or expect any "repentances" or "reformations" as prior conditions to help. They present no special claims to righteousness, austerity of life or devotion to principles superior to other men's; rather this group, free of any rigid restricting dogma or methodology, let the problems encountered dictate the solutions.

It is a refreshing experience to find such freedom and flexibility. The parish, a nondenominational ministry, works hard in the fight against drug addiction, bad housing, lack of political representation, every form of injustice; they cooperate in furnishing legal, medical, and economic aid; head up community action projects; plan summer activities for adults and children; besides furnishing a personal sense of worth to these people hit by the most devastating, depersonalizing impact of industrial society. Understanding that their efforts cannot realize immediate results, they nonetheless labor to bring a new way of life to these estranged people. In short, it is a total ministry, work that demands genuine respect and that needs support, and in the final analysis, testifies to their conviction that there is, in the Christian faith, a dynamic that can transform society and give strength to the weak in the fight for justice.

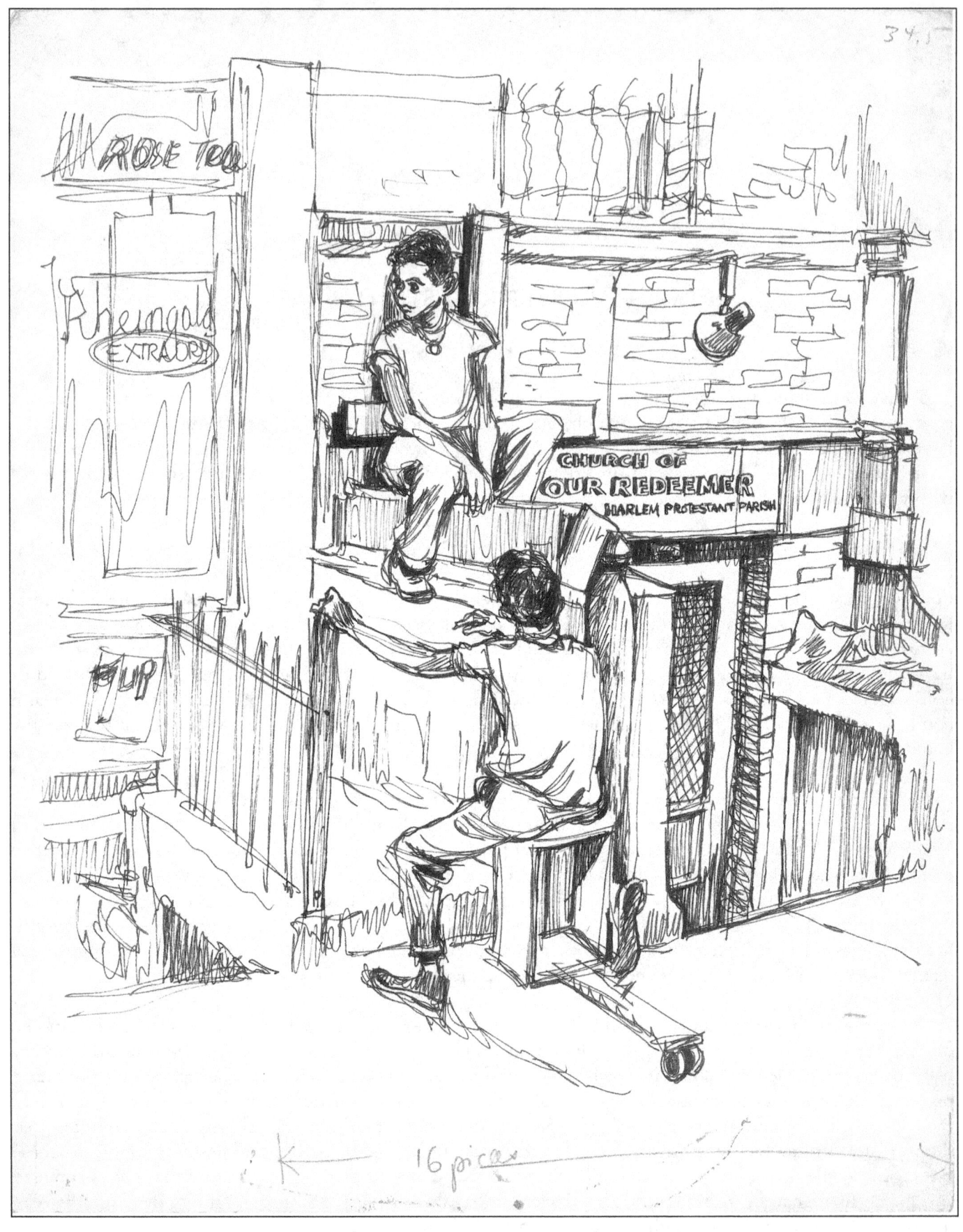

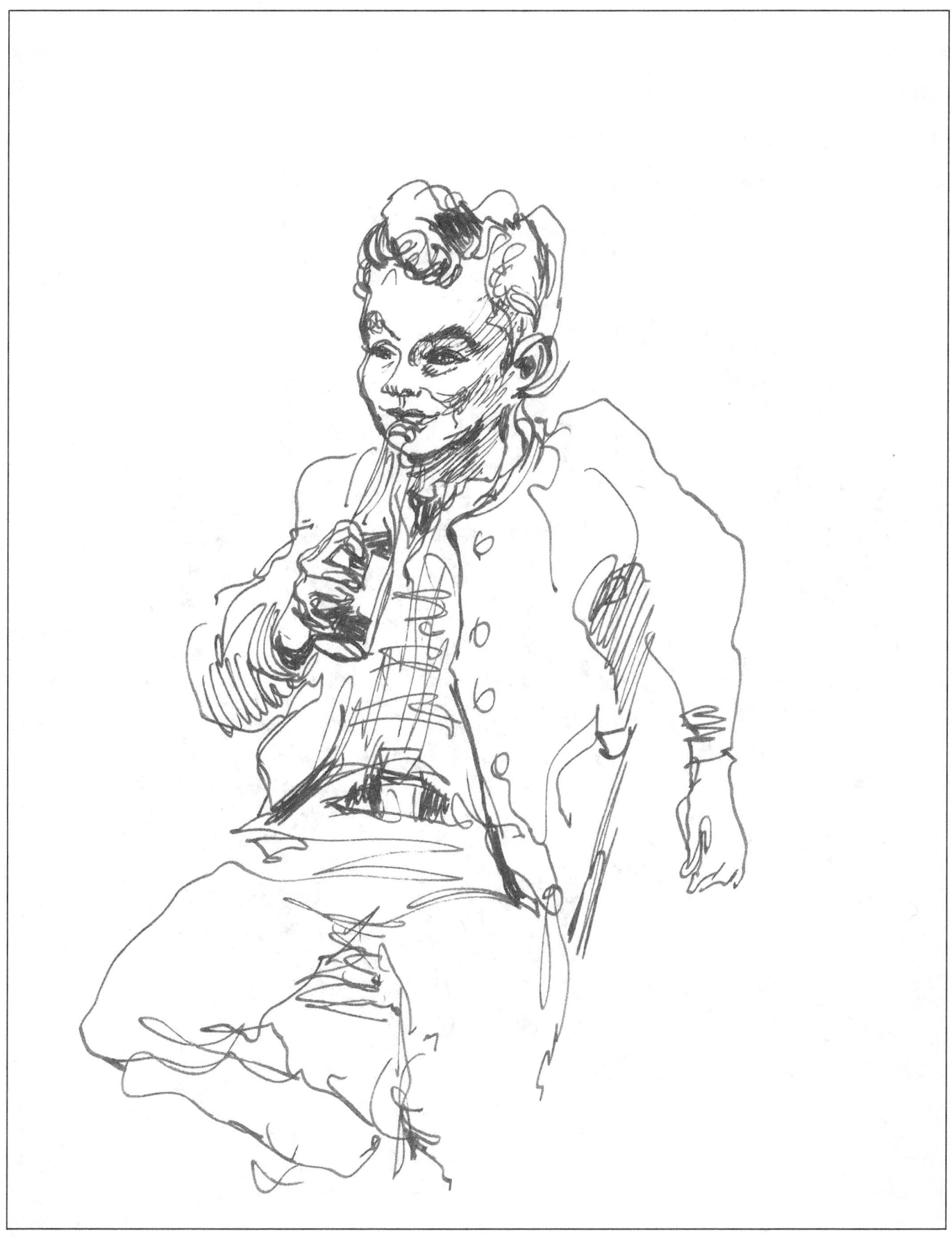

# JOSEPH W. PAPIN

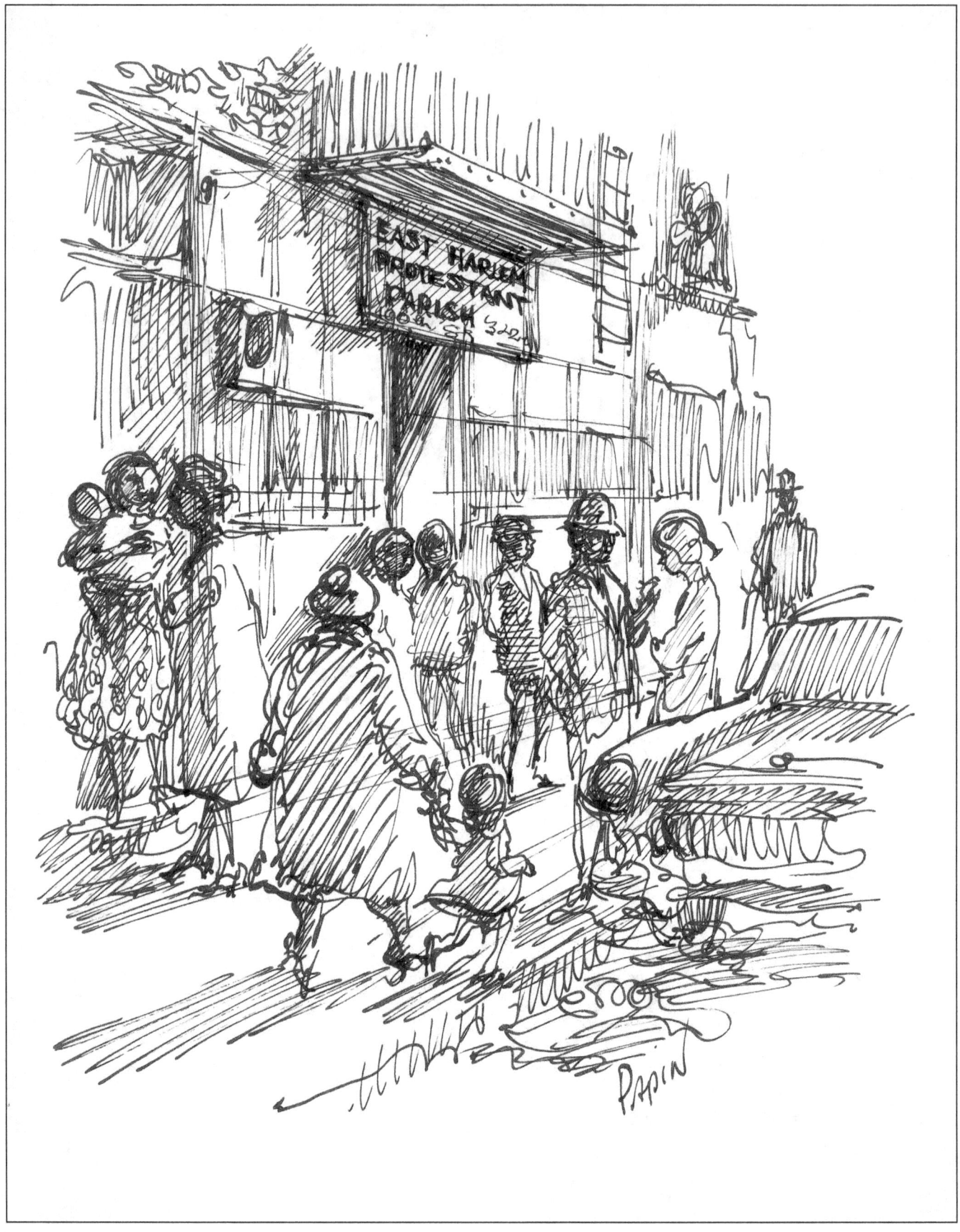

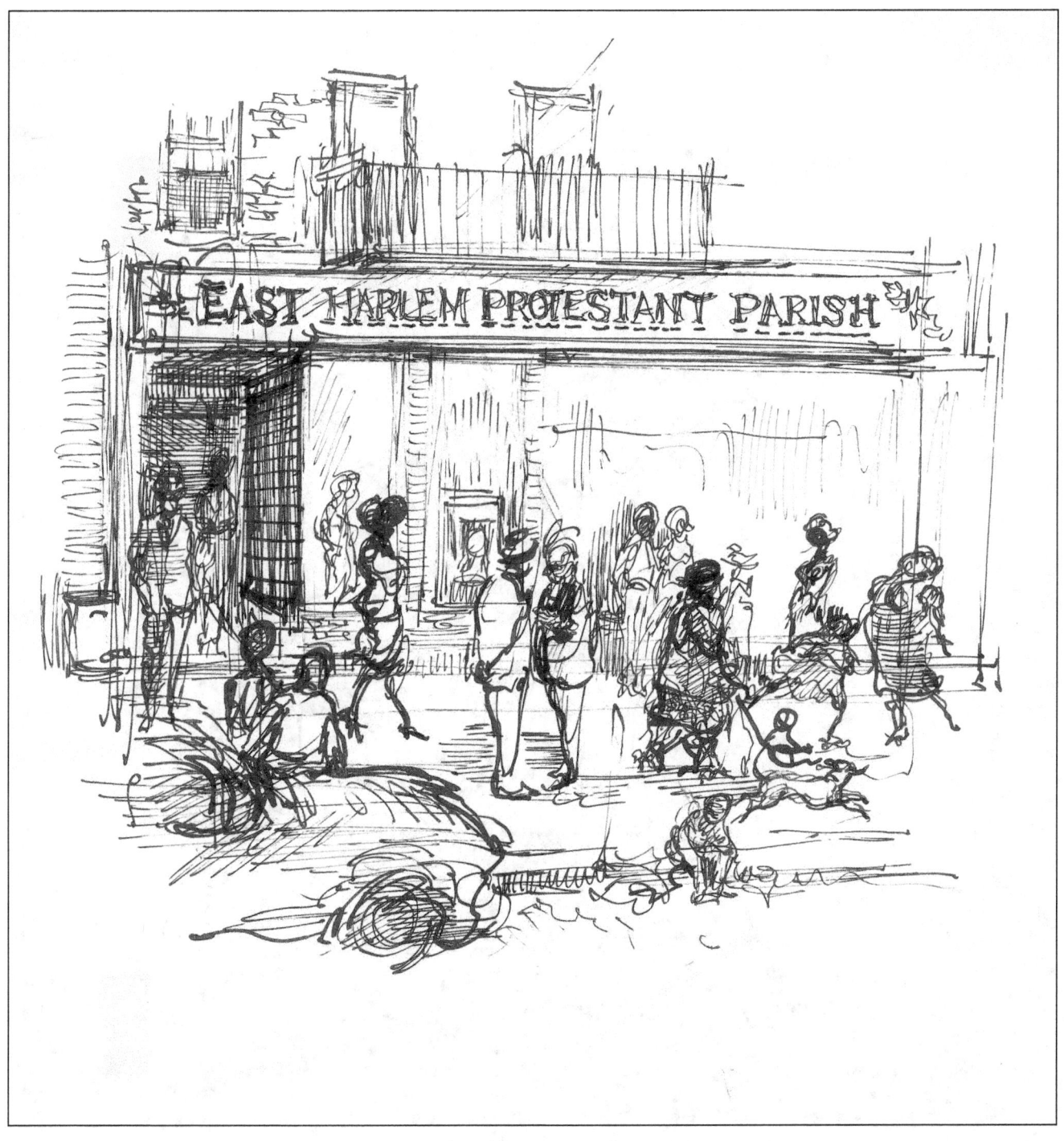

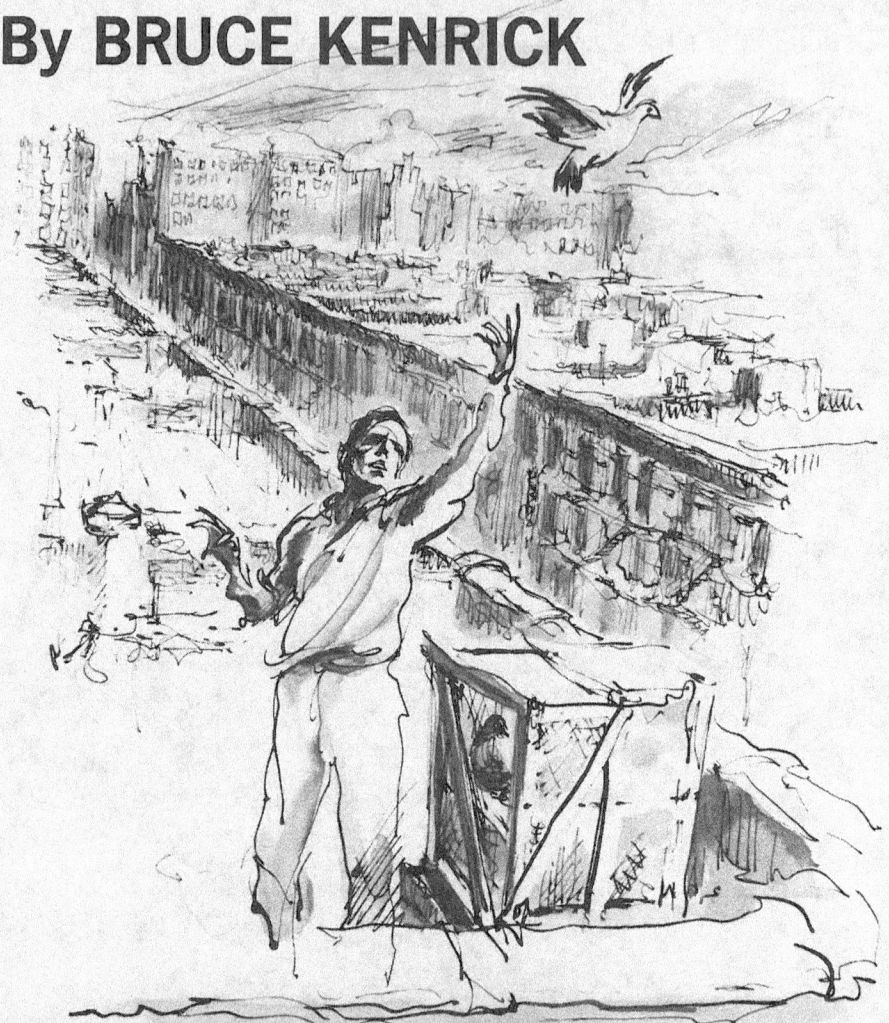

Illustrated by Joseph Papin

Published by Harper, 1962

# THE STREET IS MY STUDIO: EAST HARLEM PROTESTANT PARISH

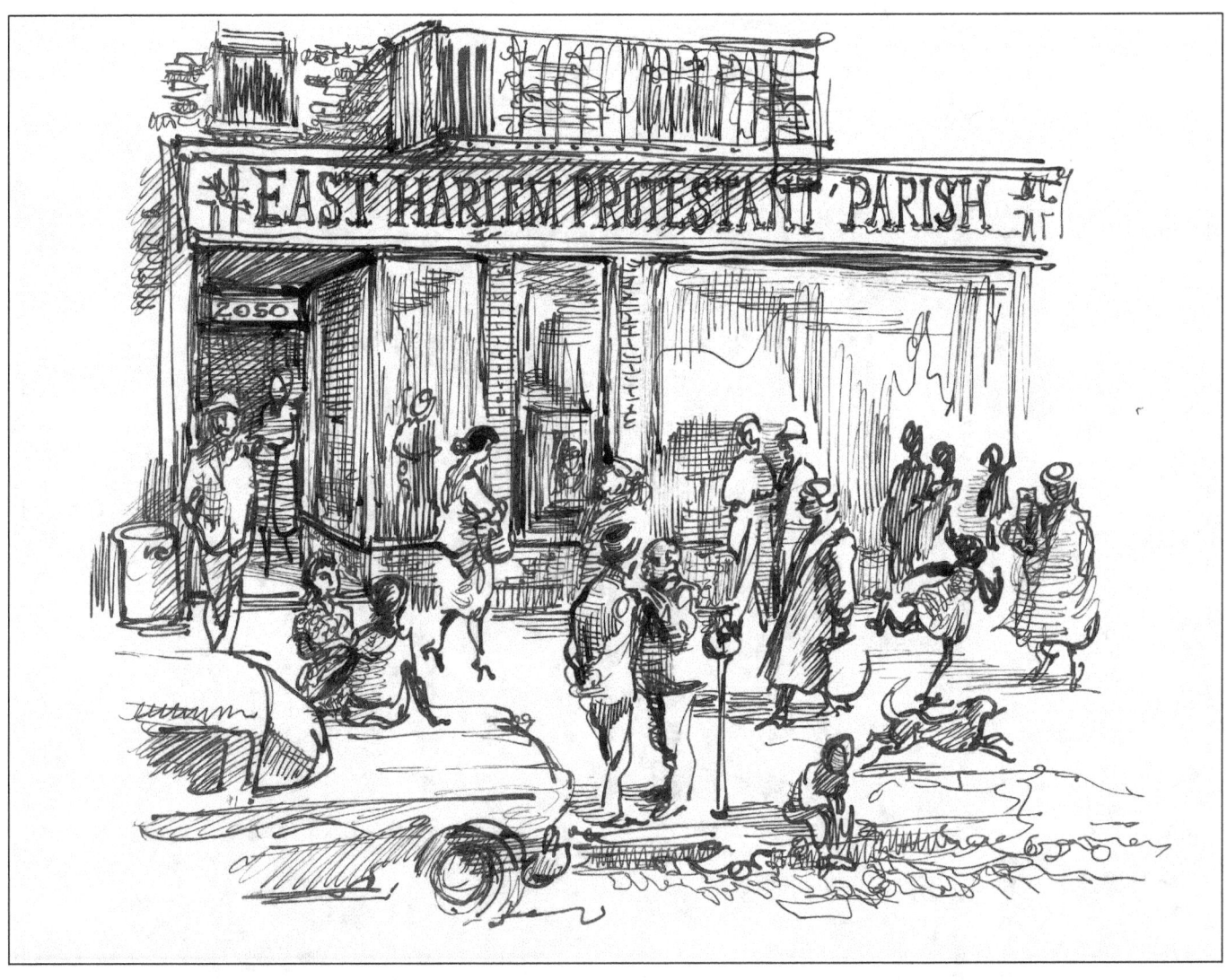

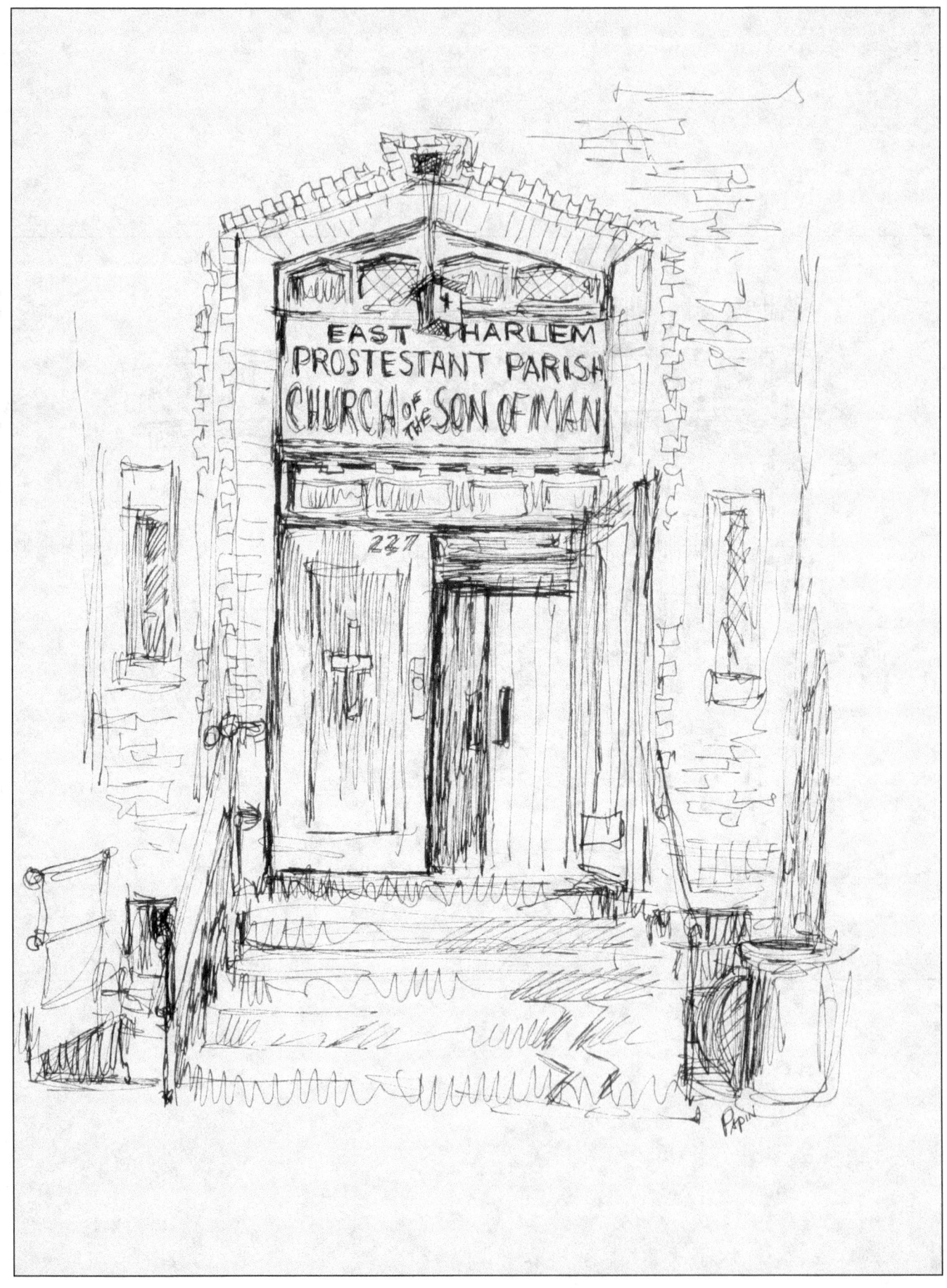

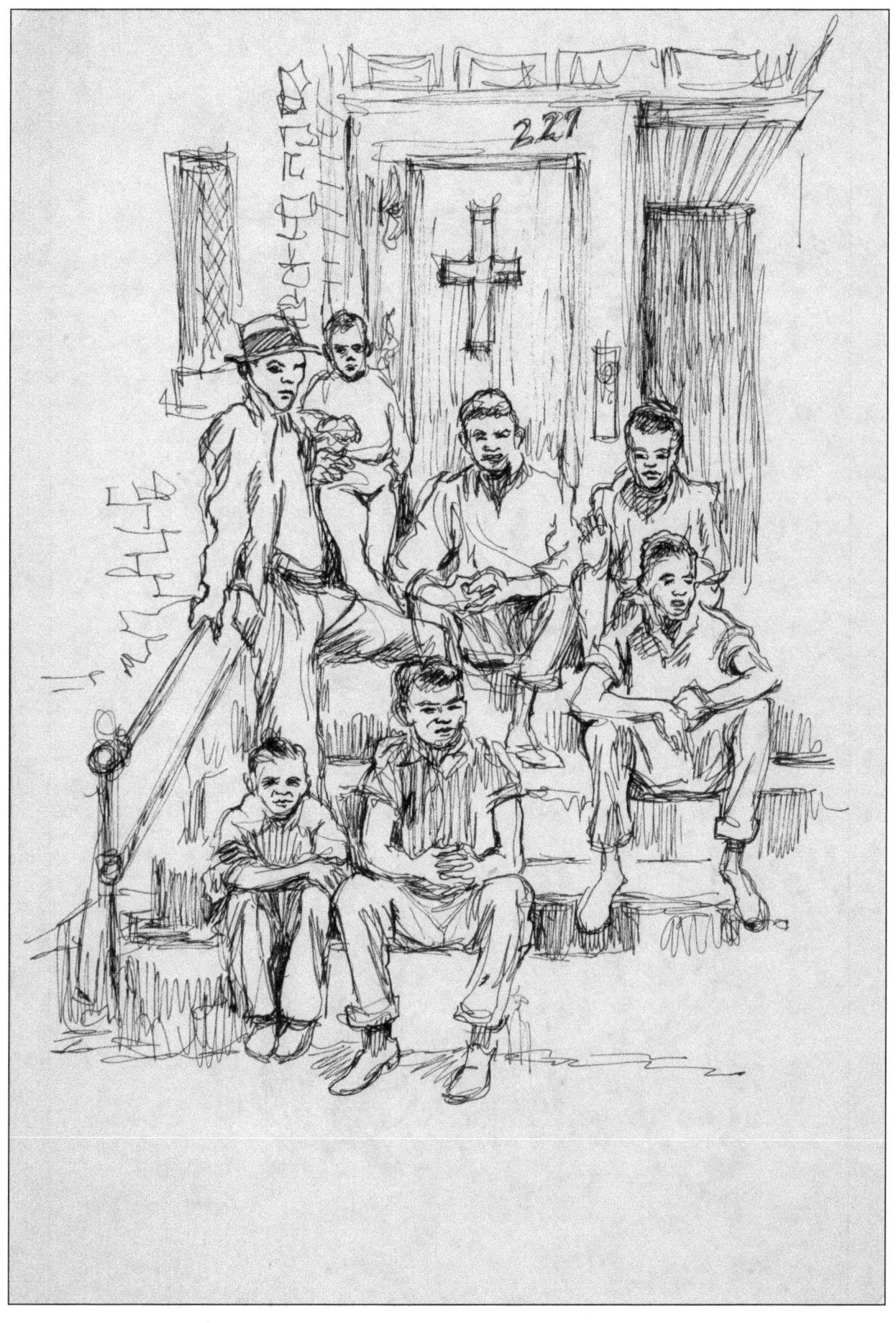

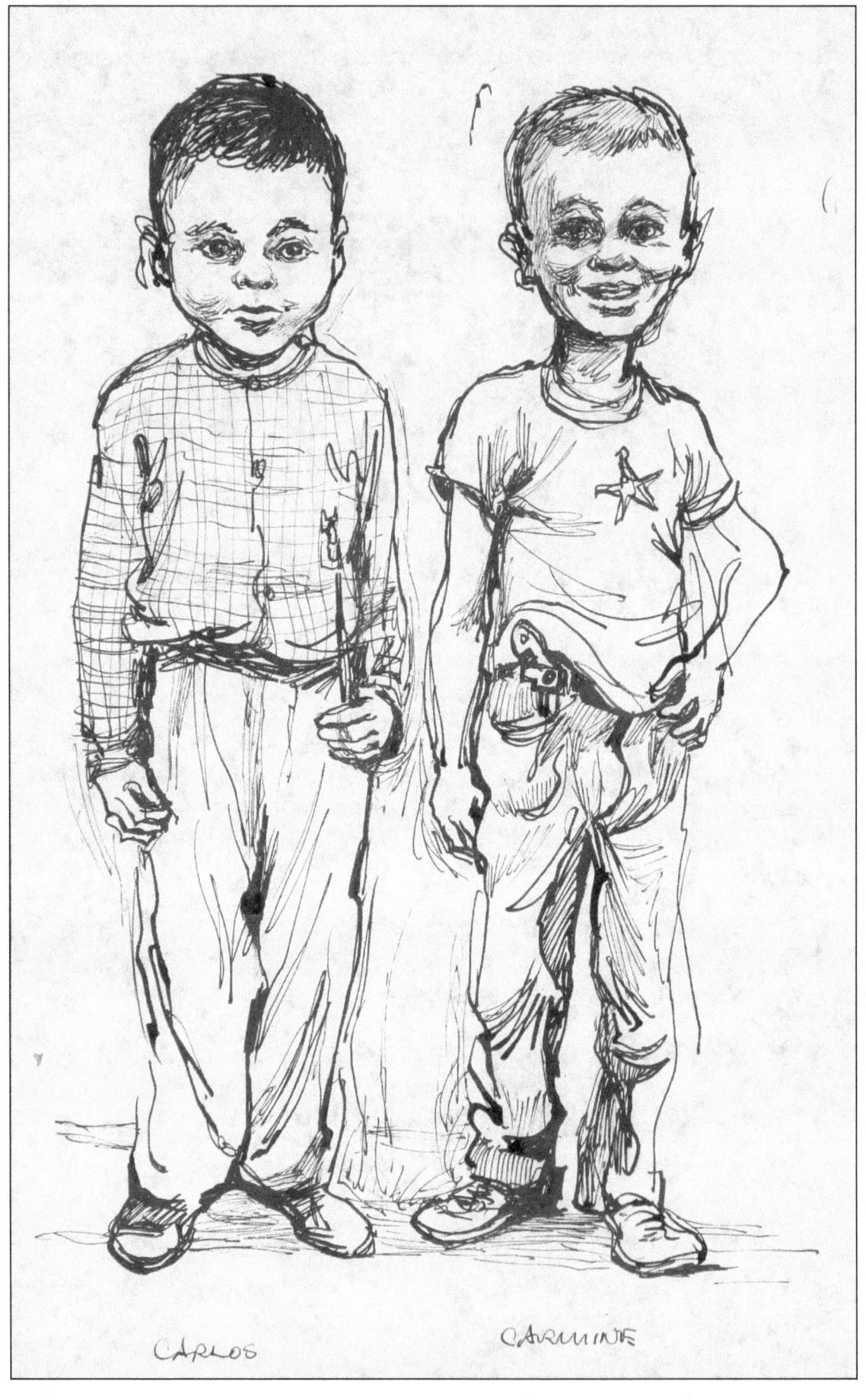

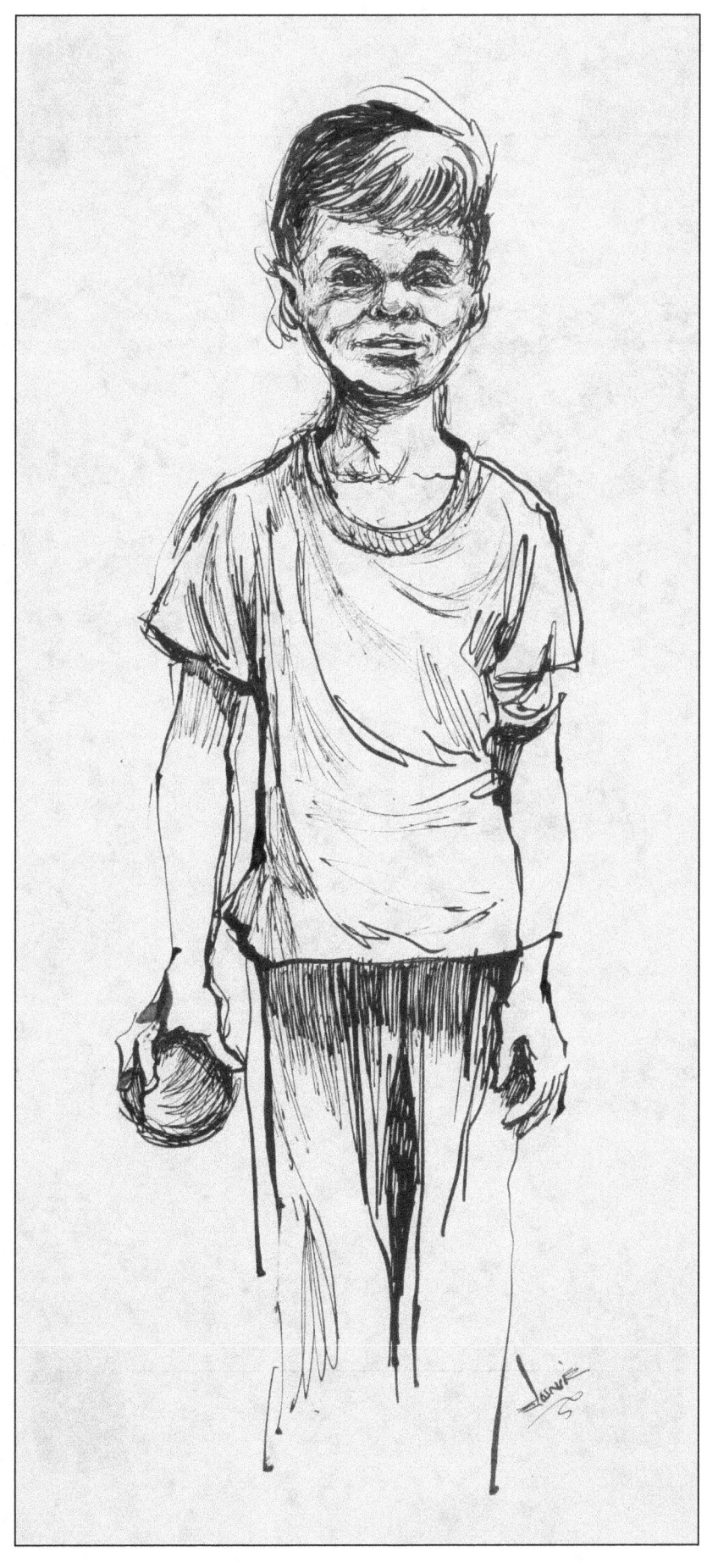

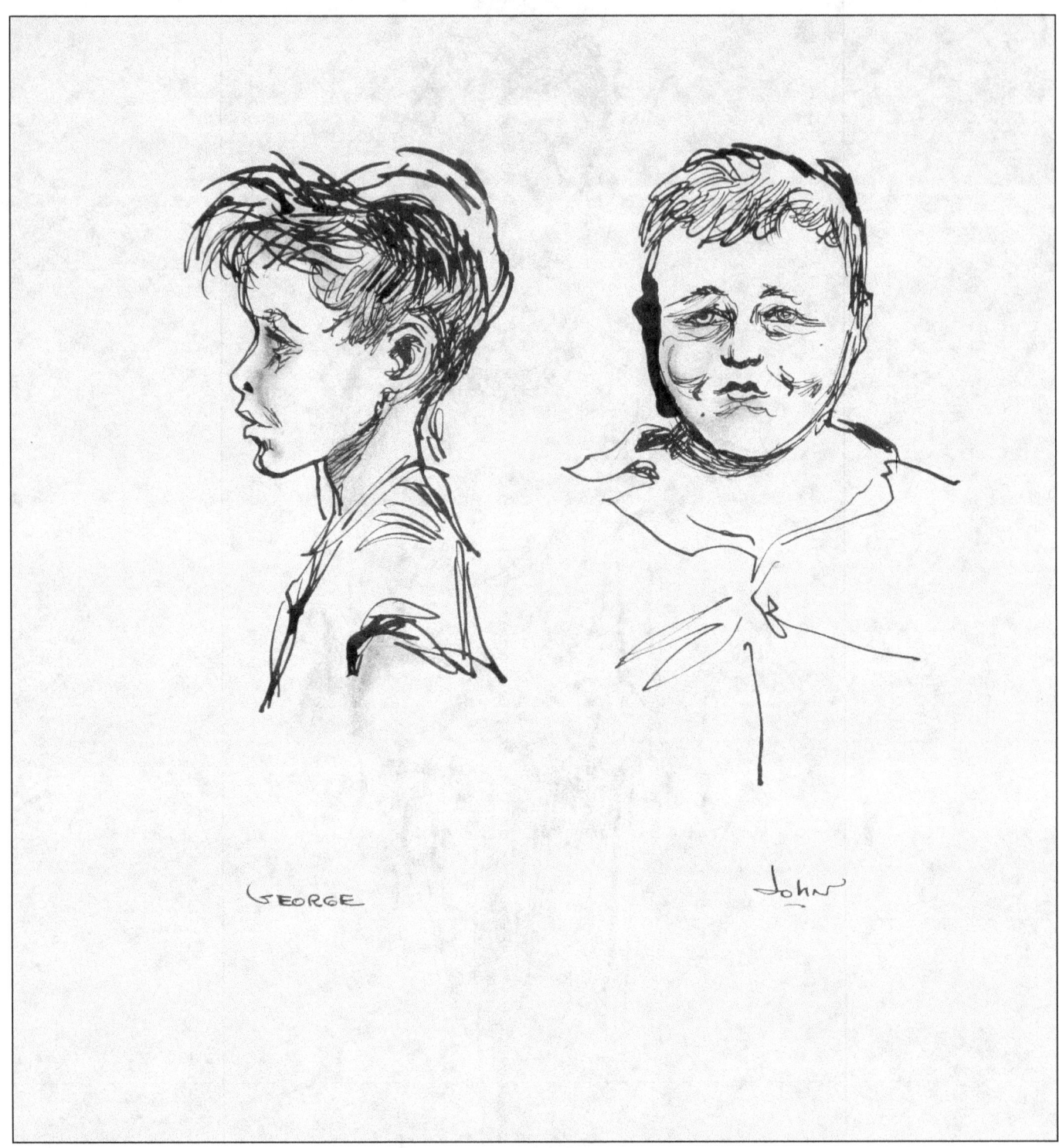

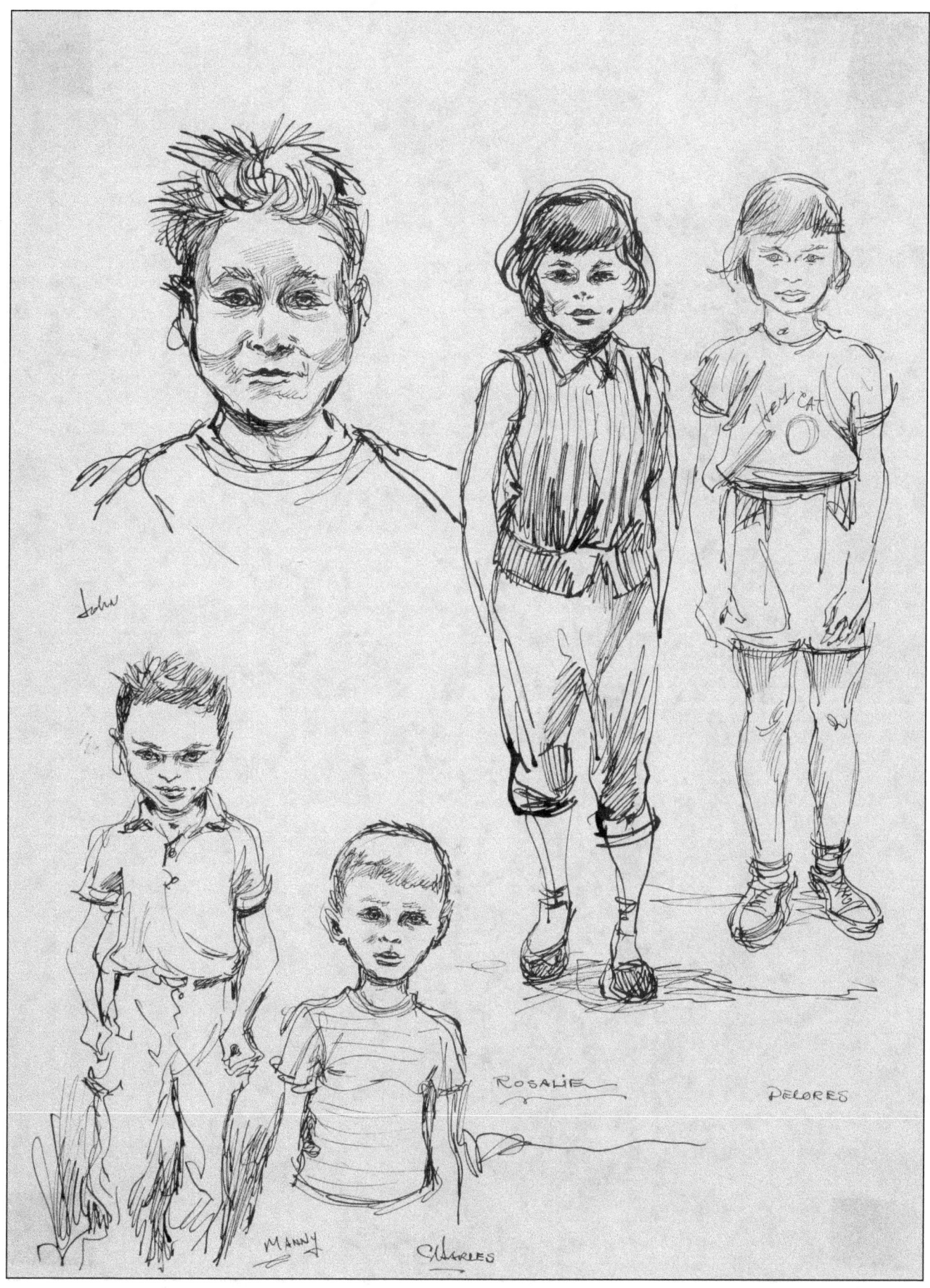

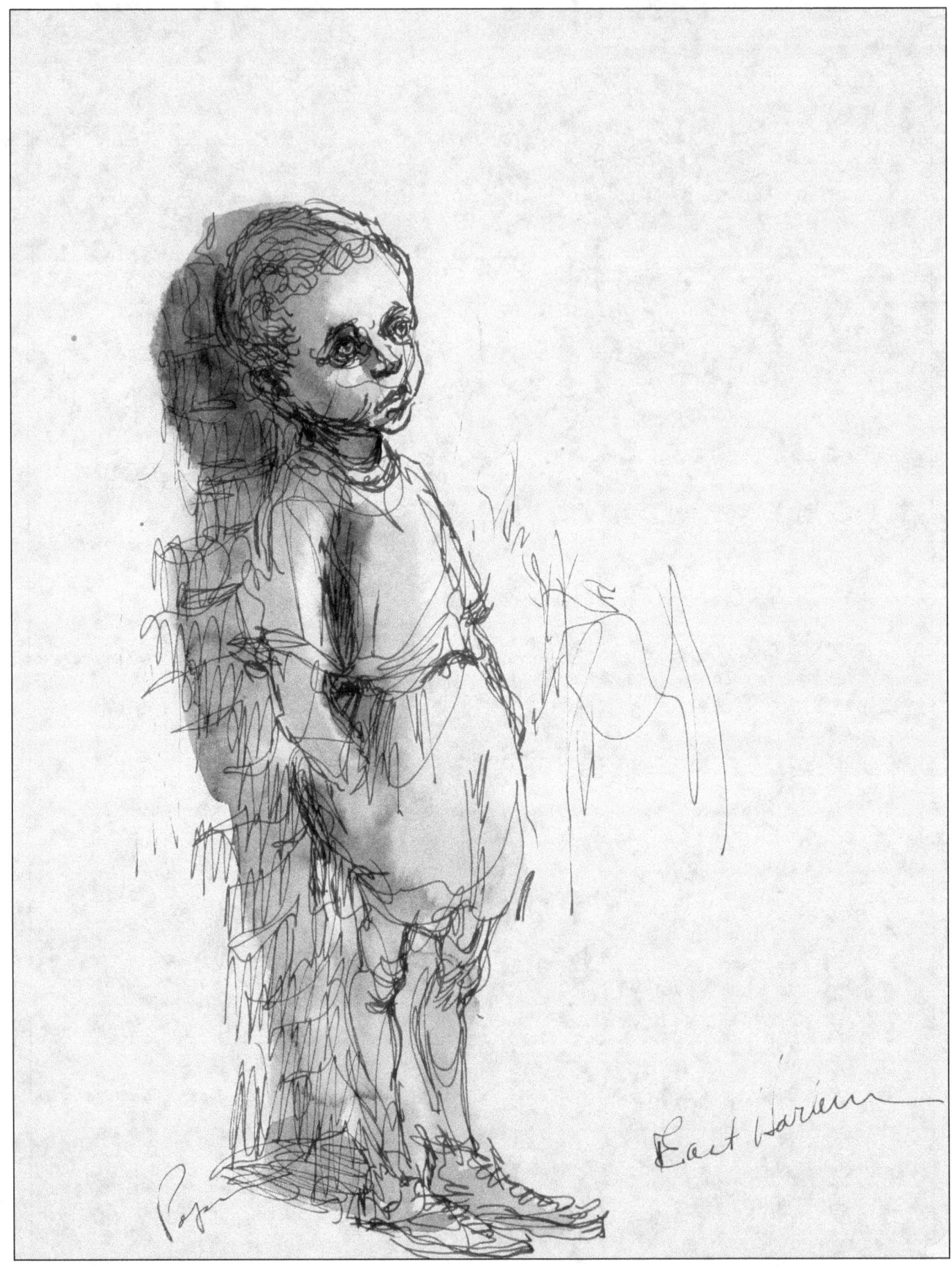

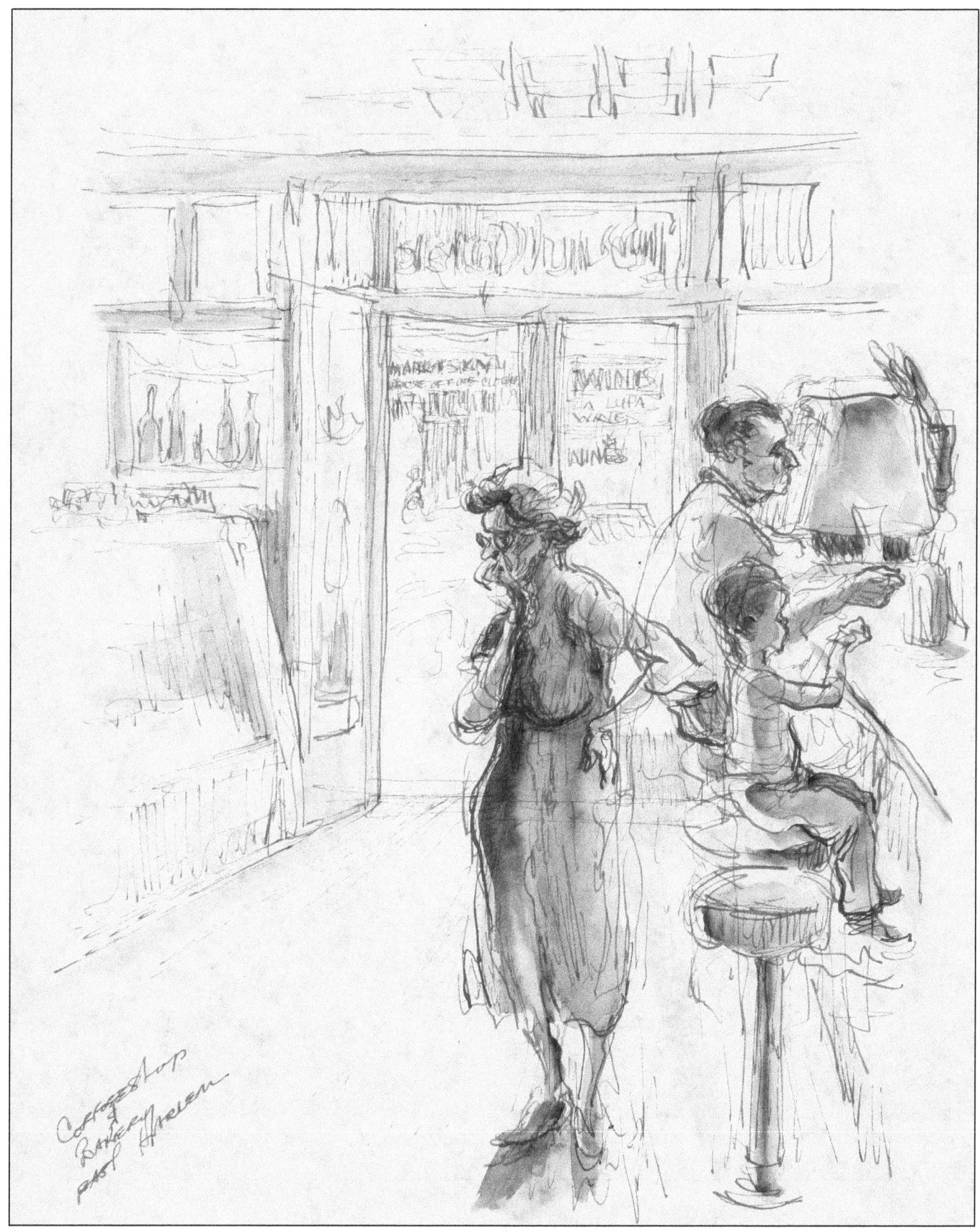

Coffee shop and bakery East Harlem

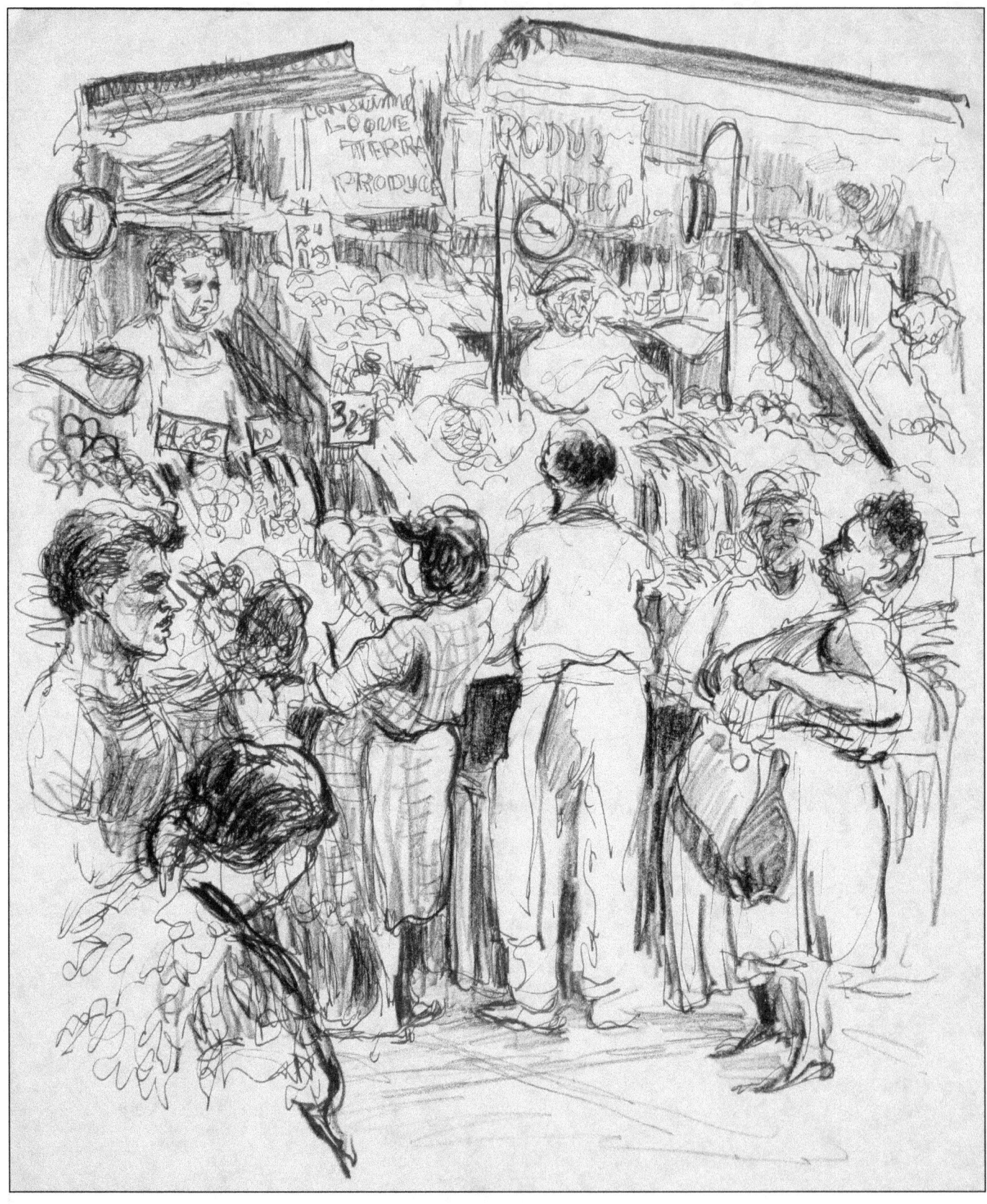

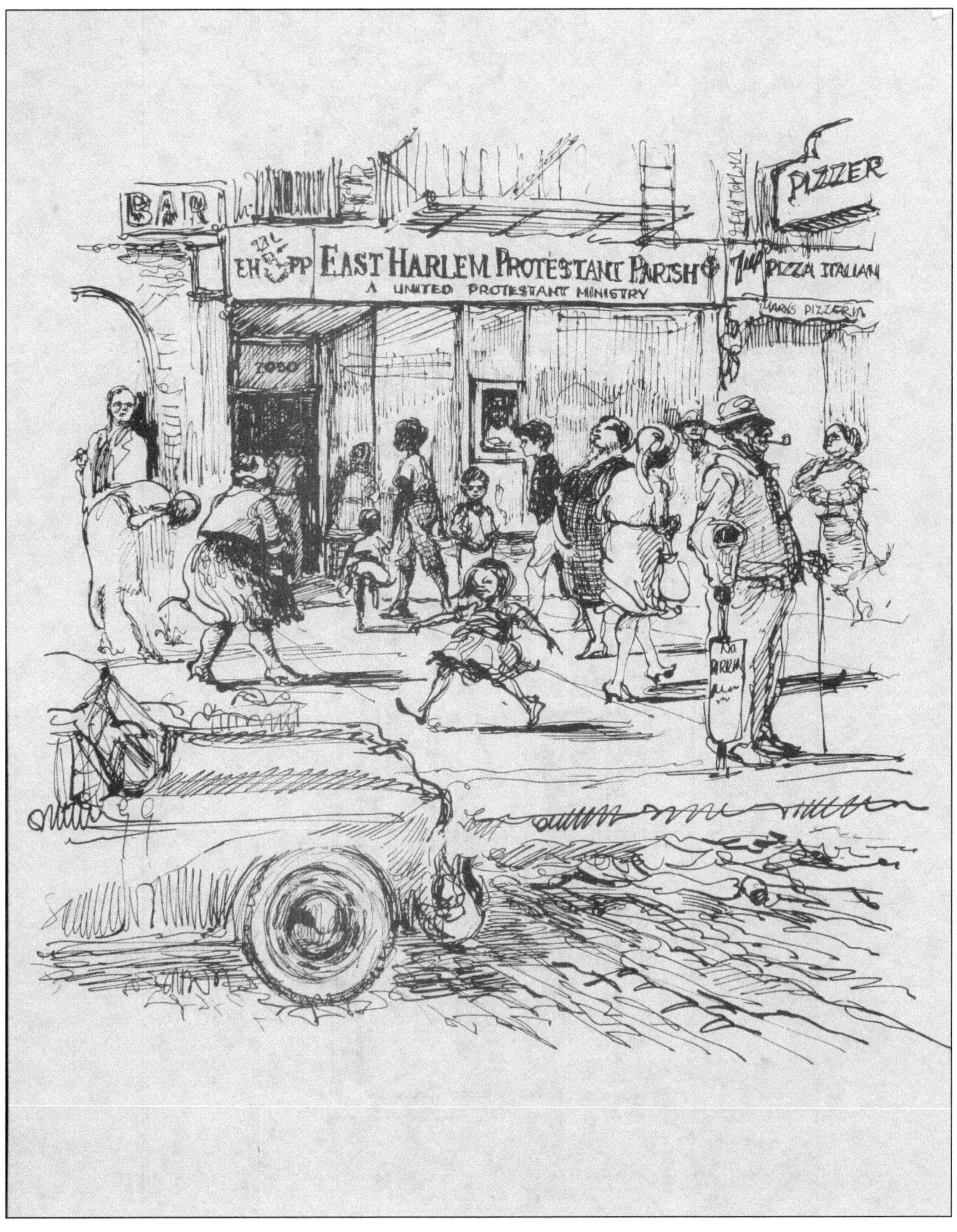

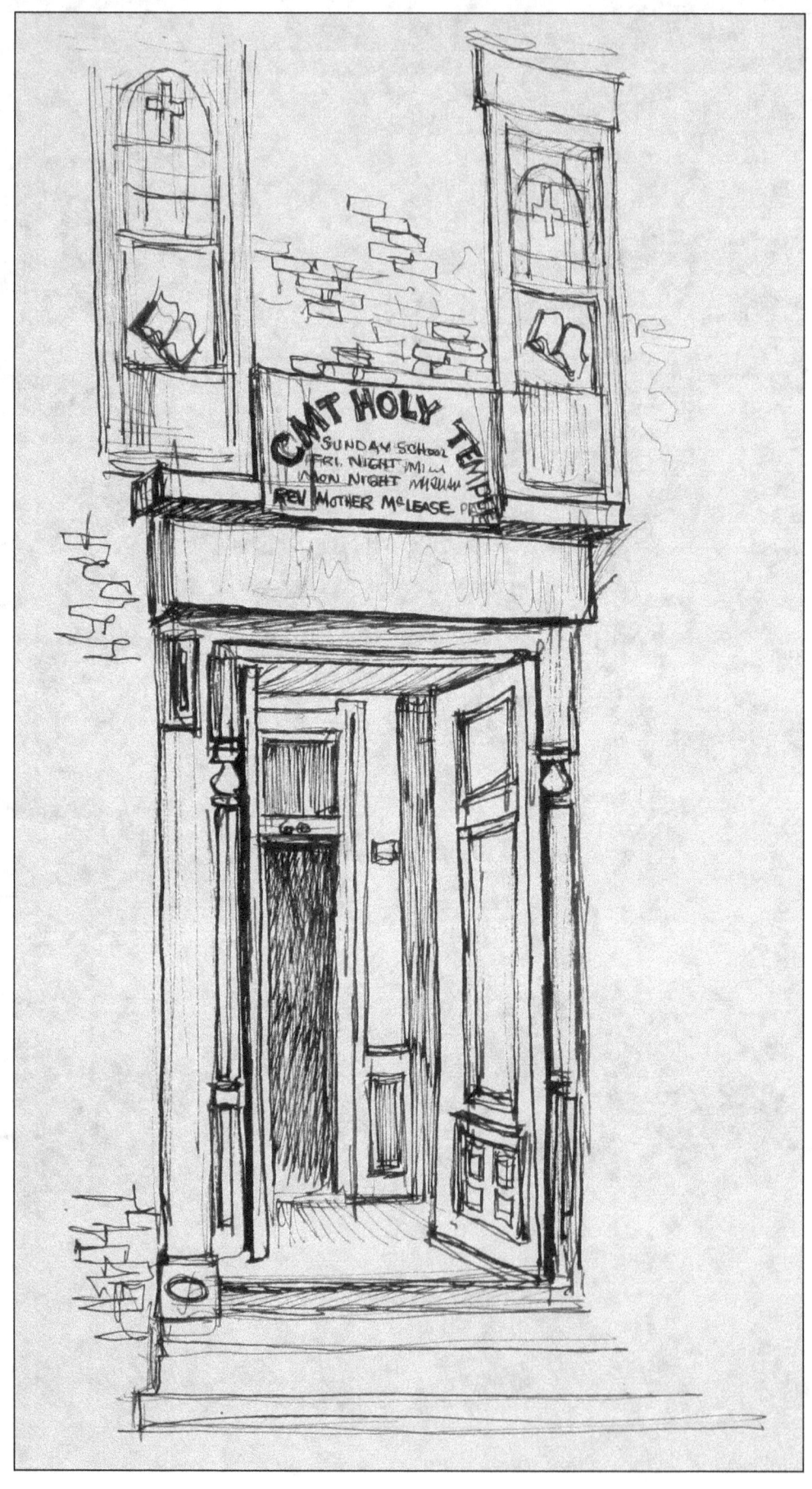

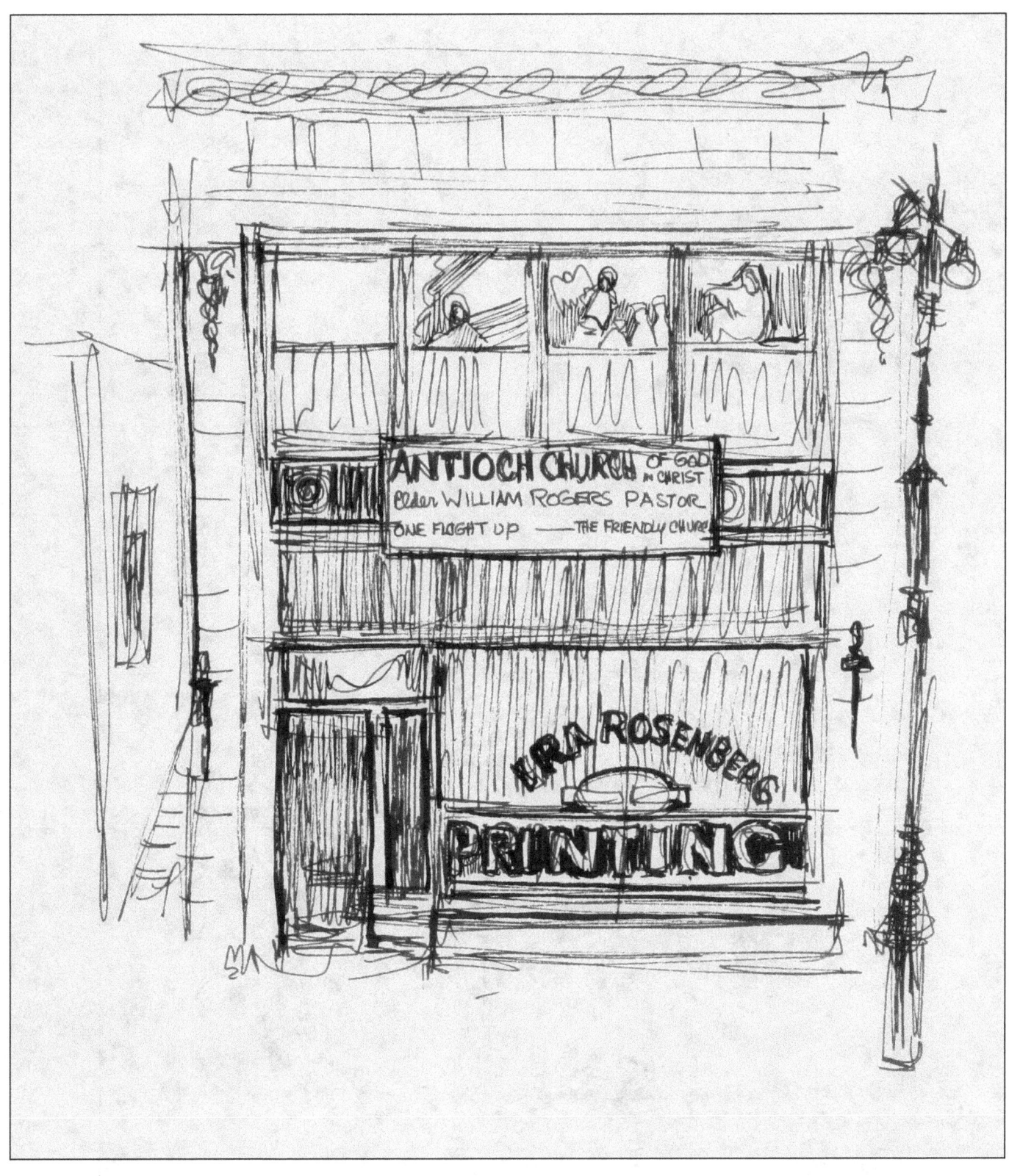

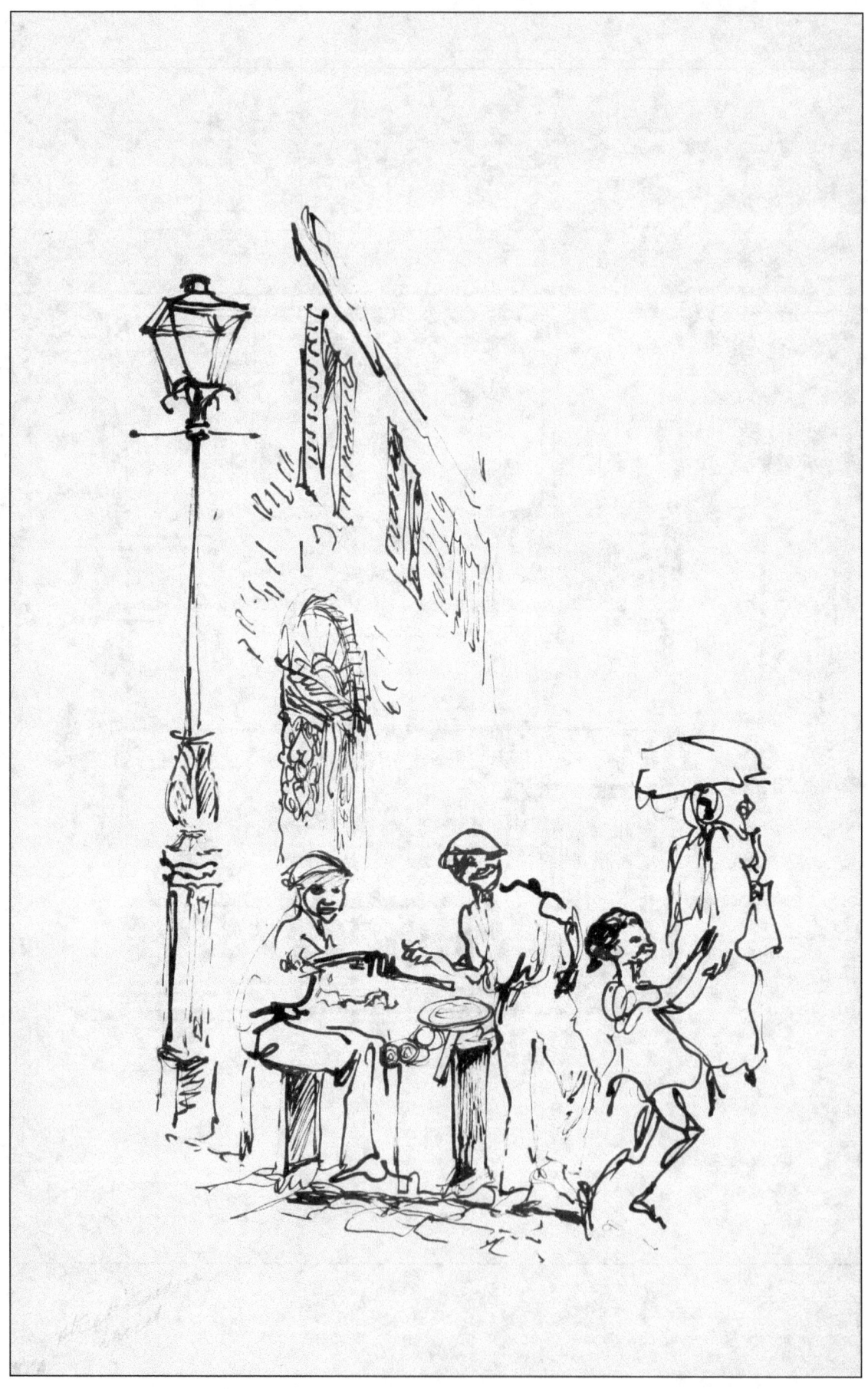

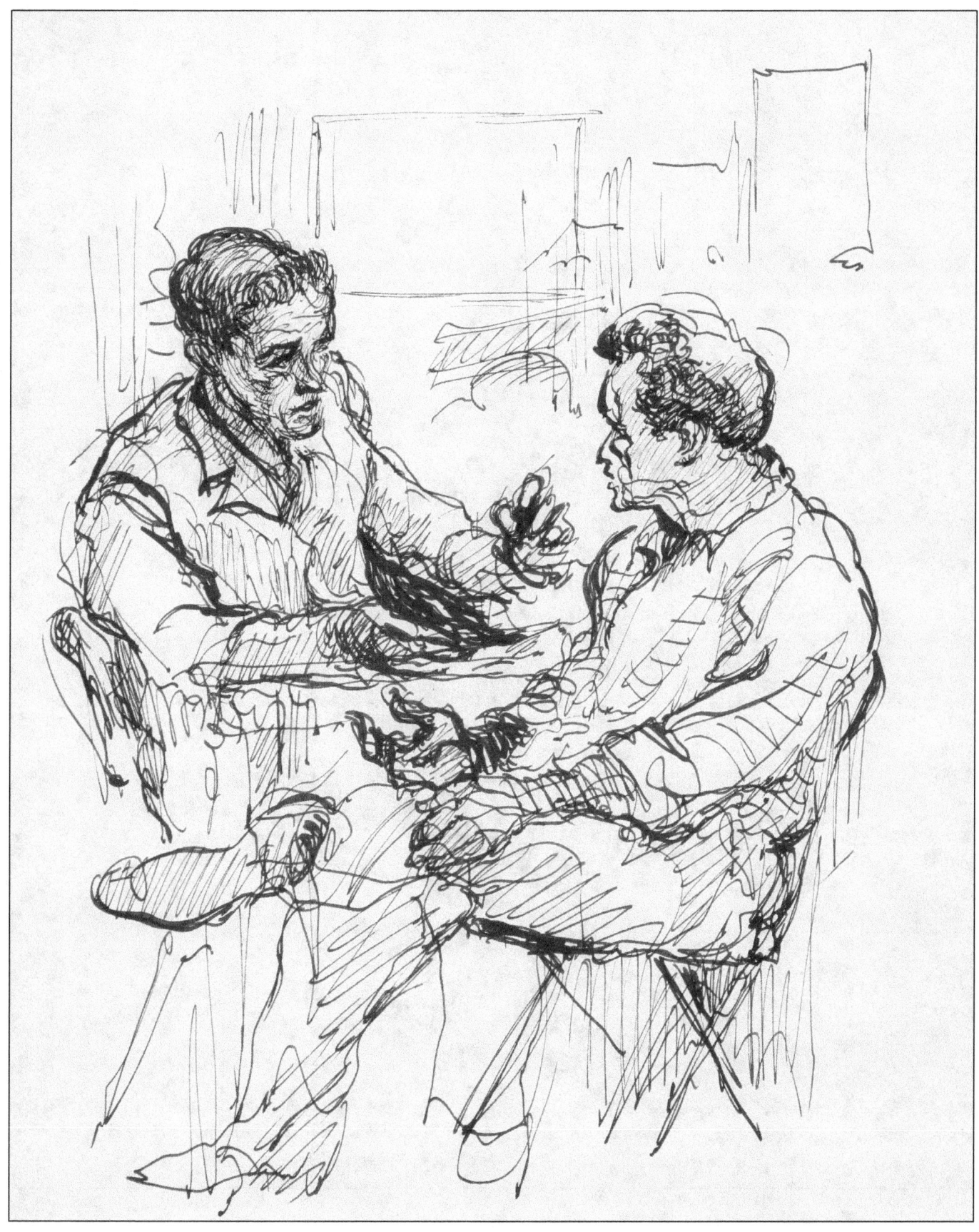

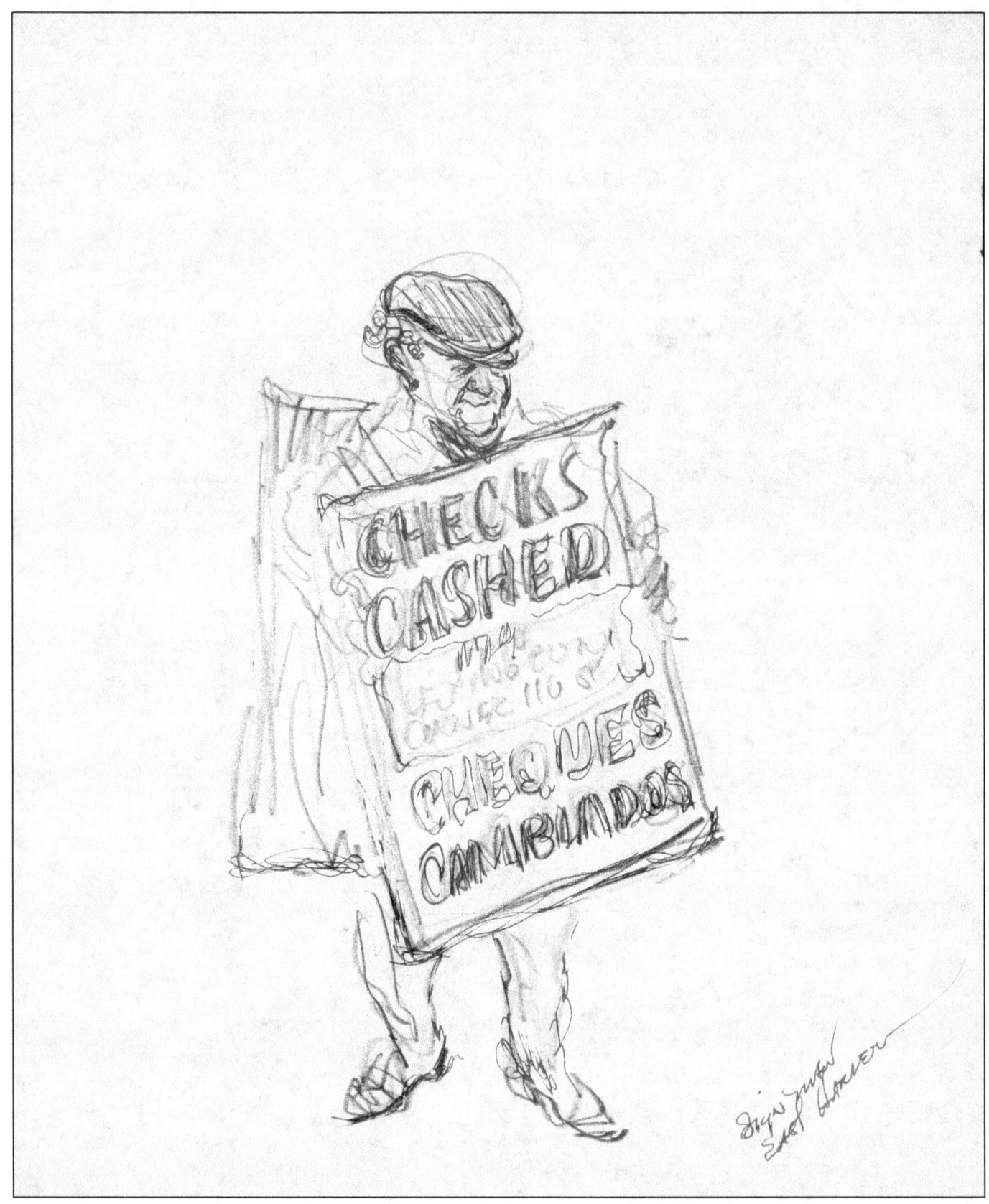

Sign man, East Harlem

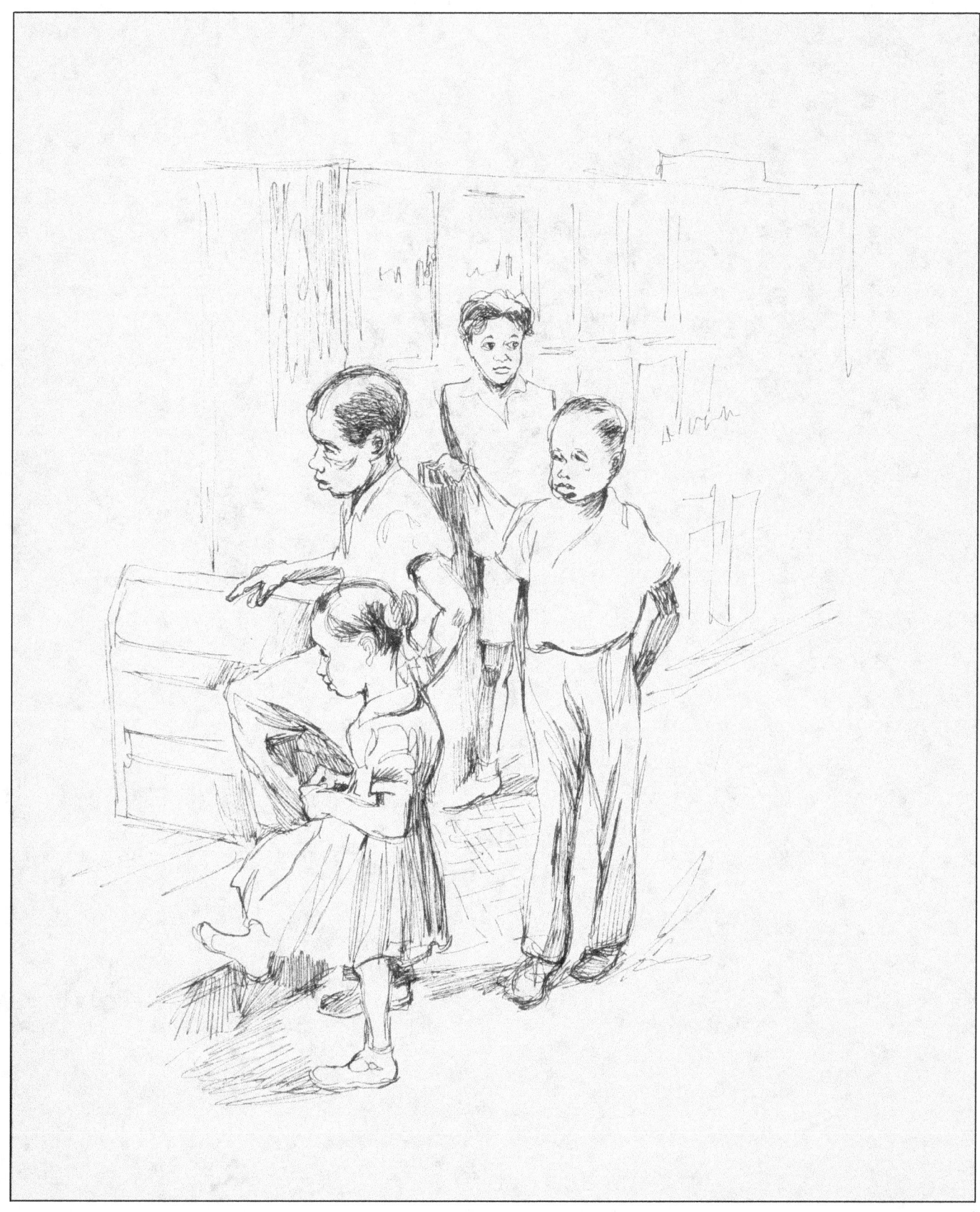

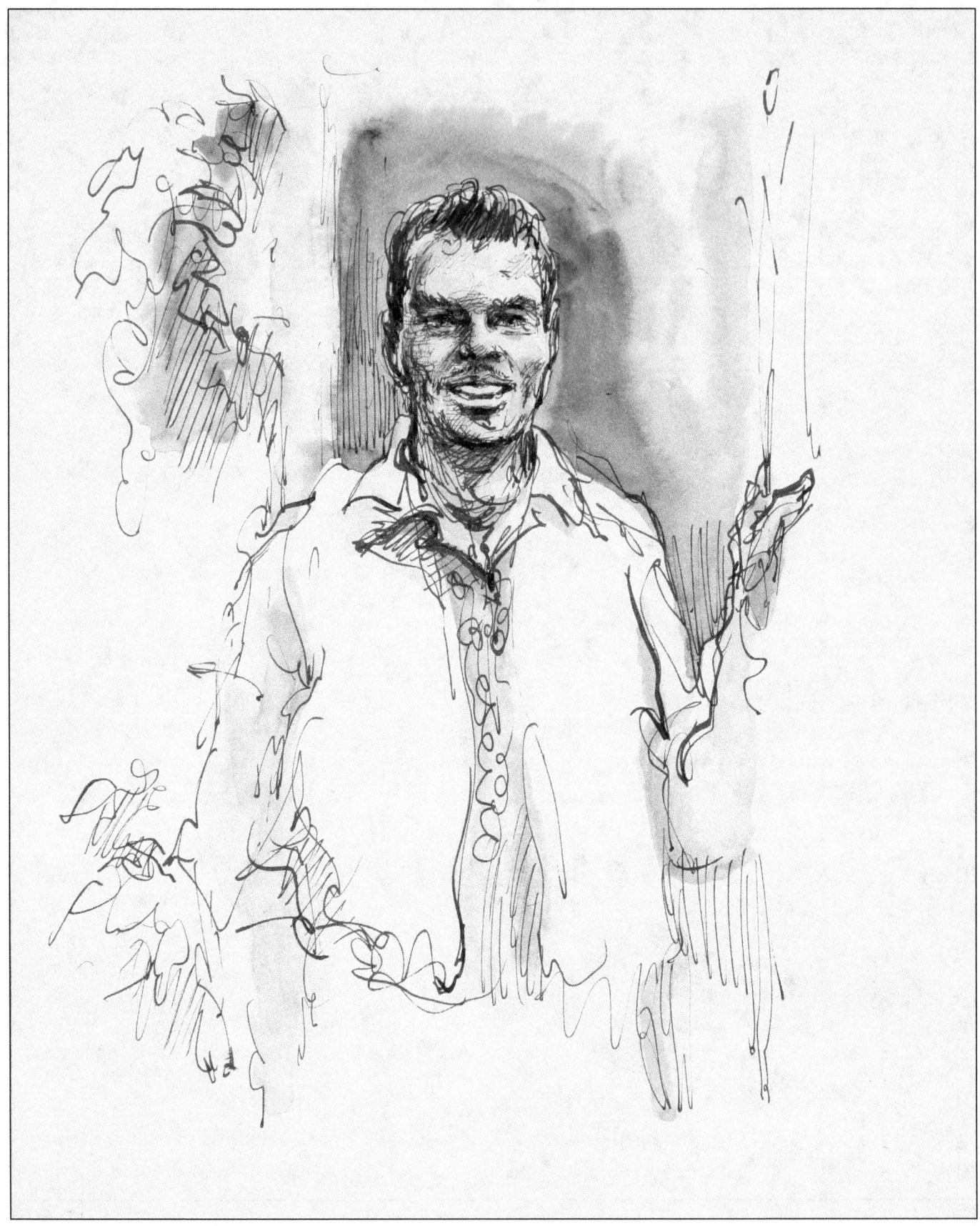

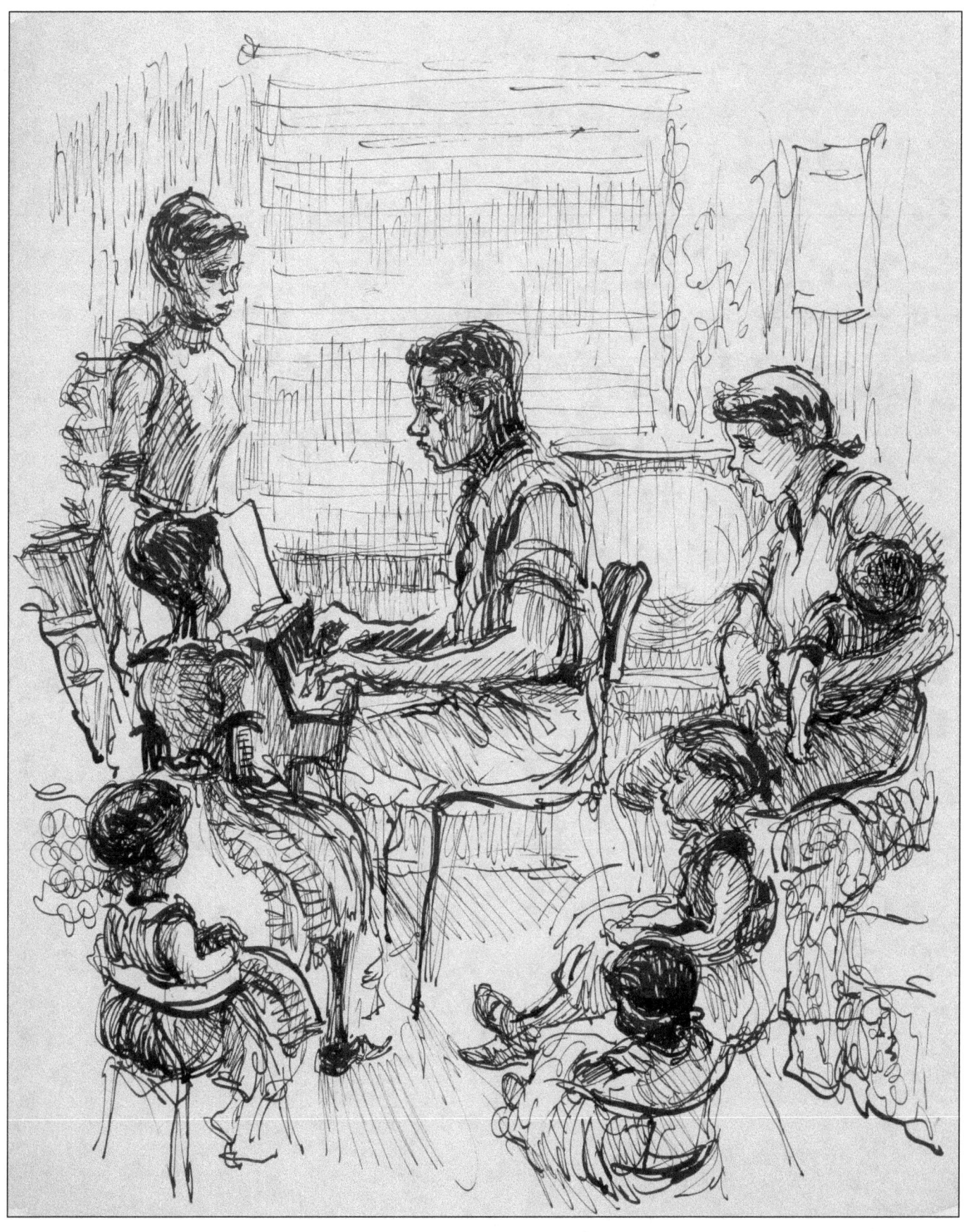

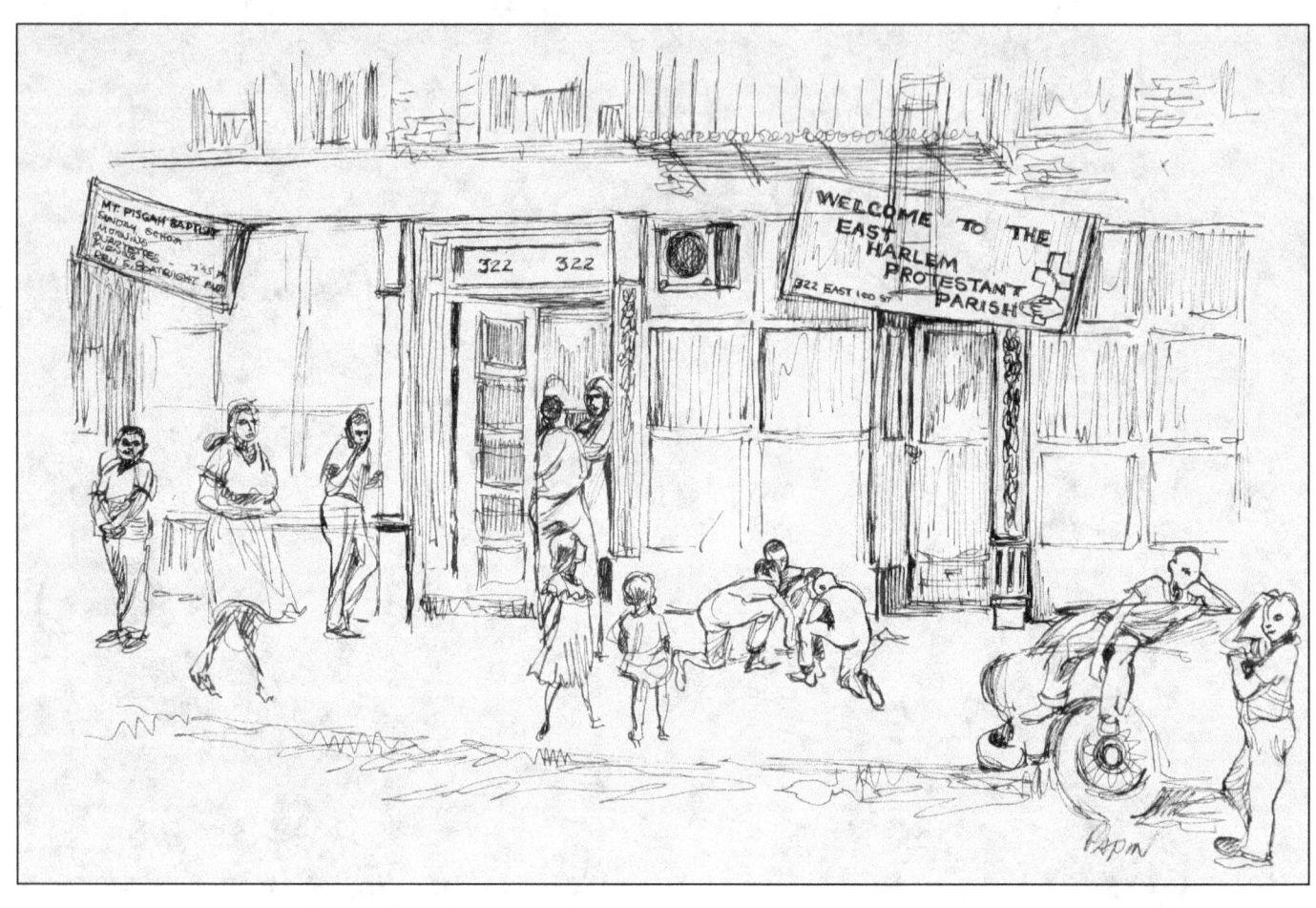

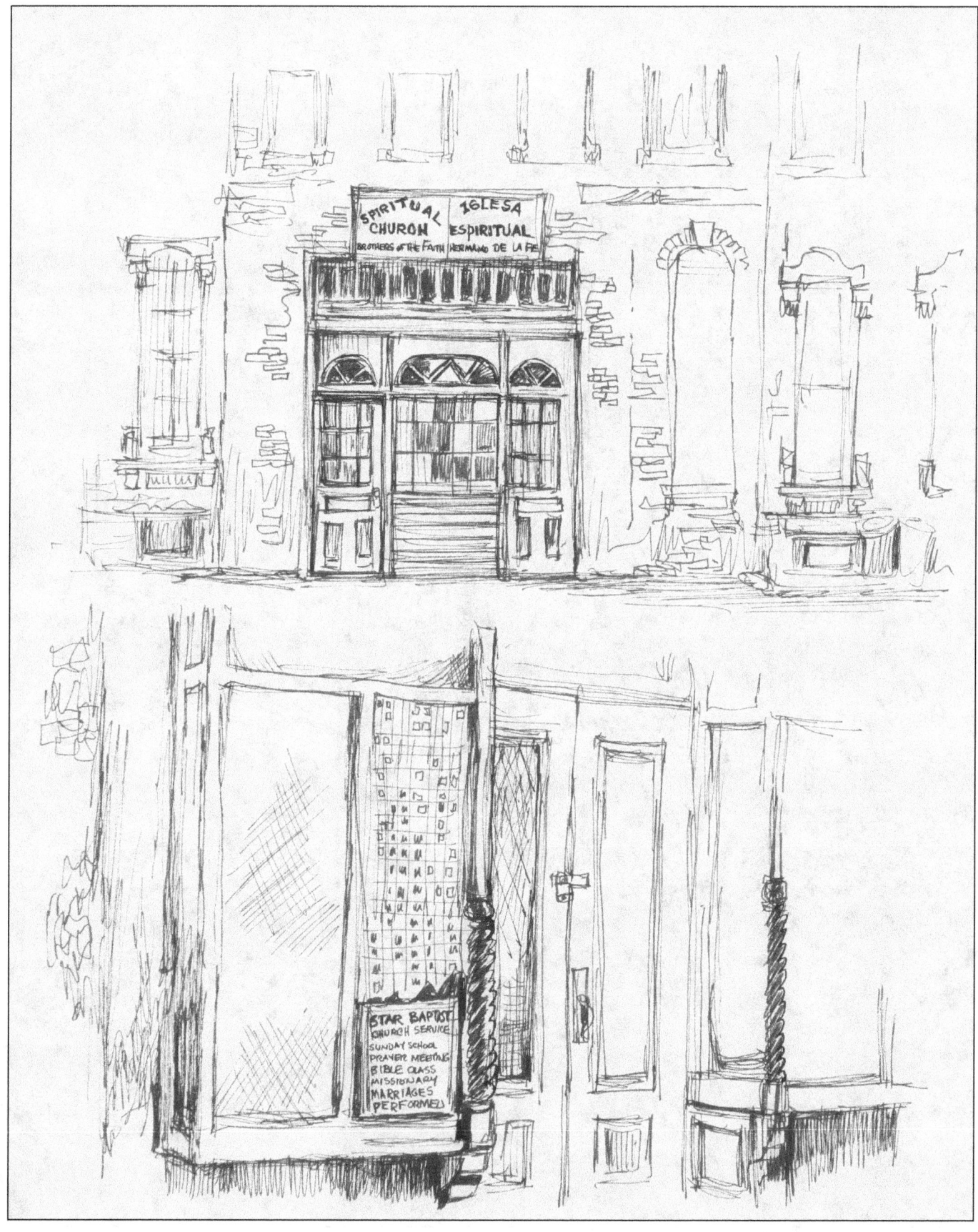

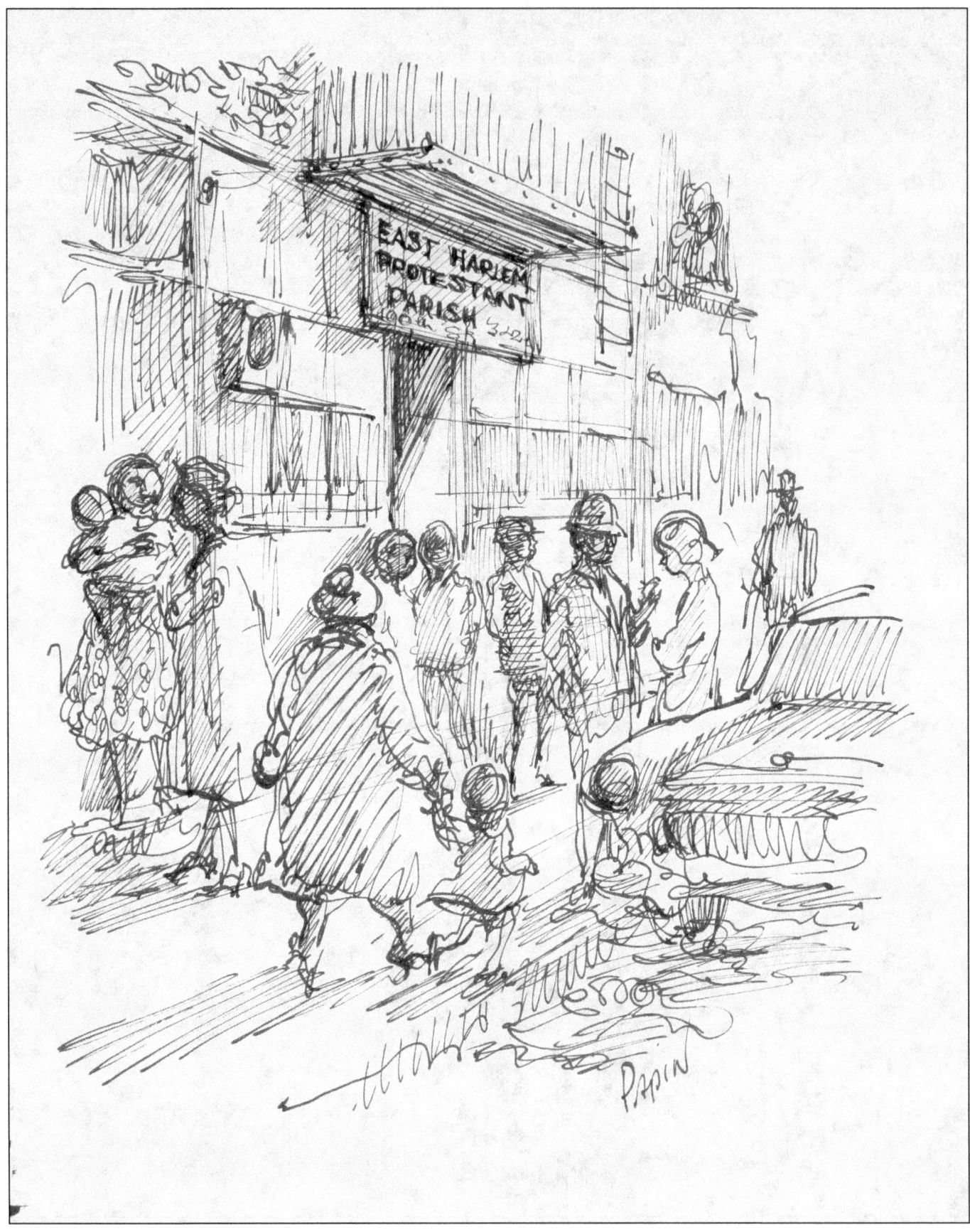

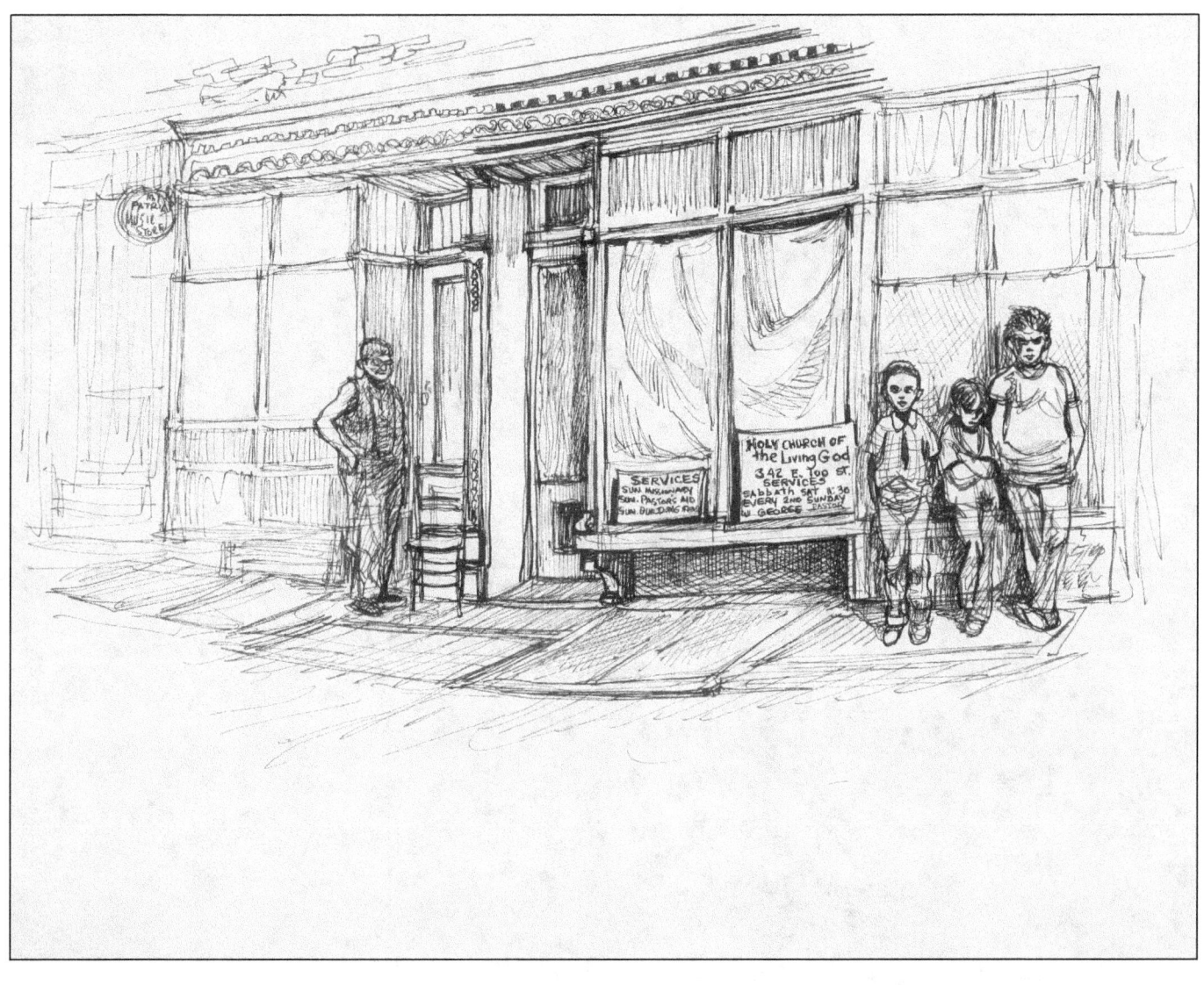

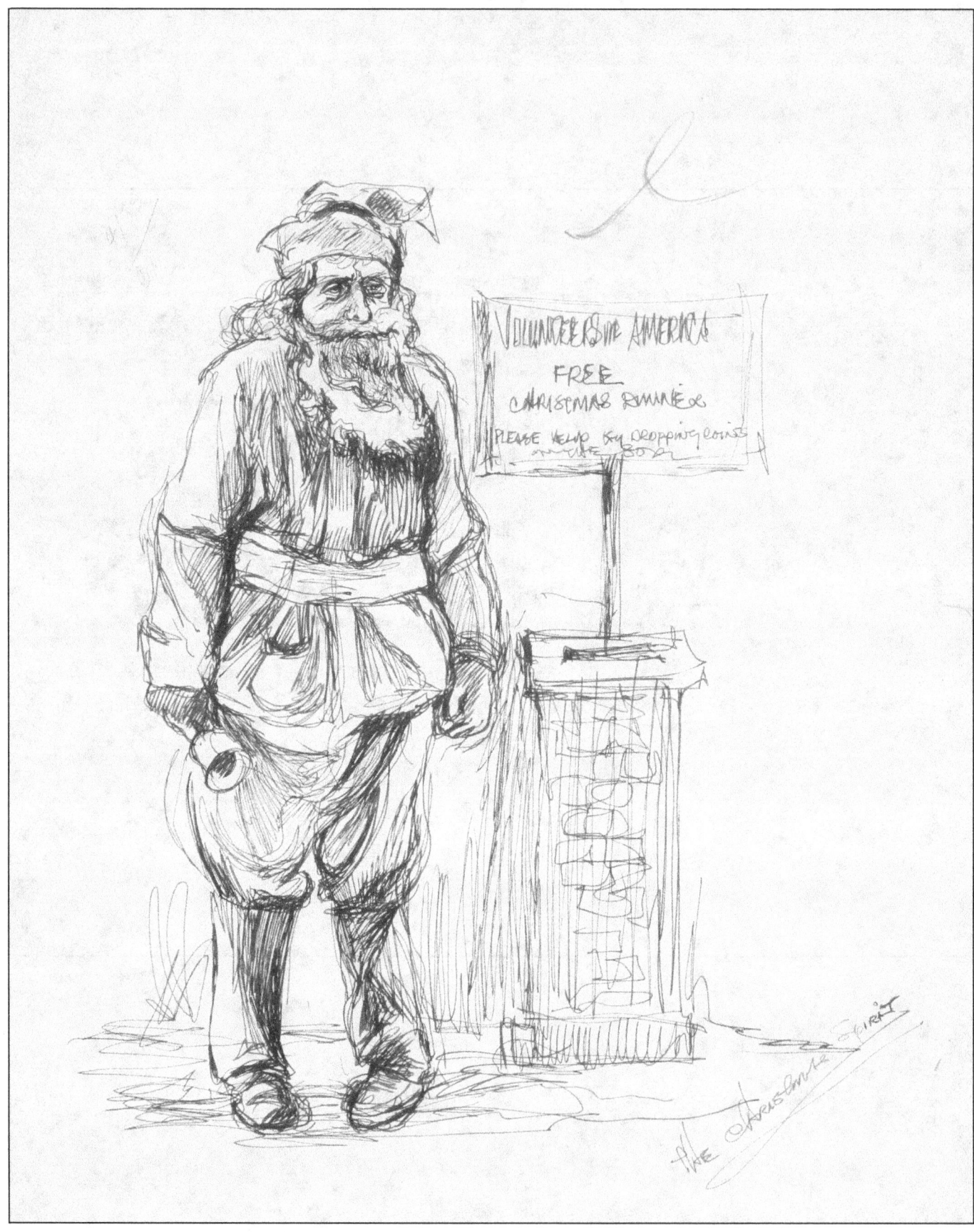

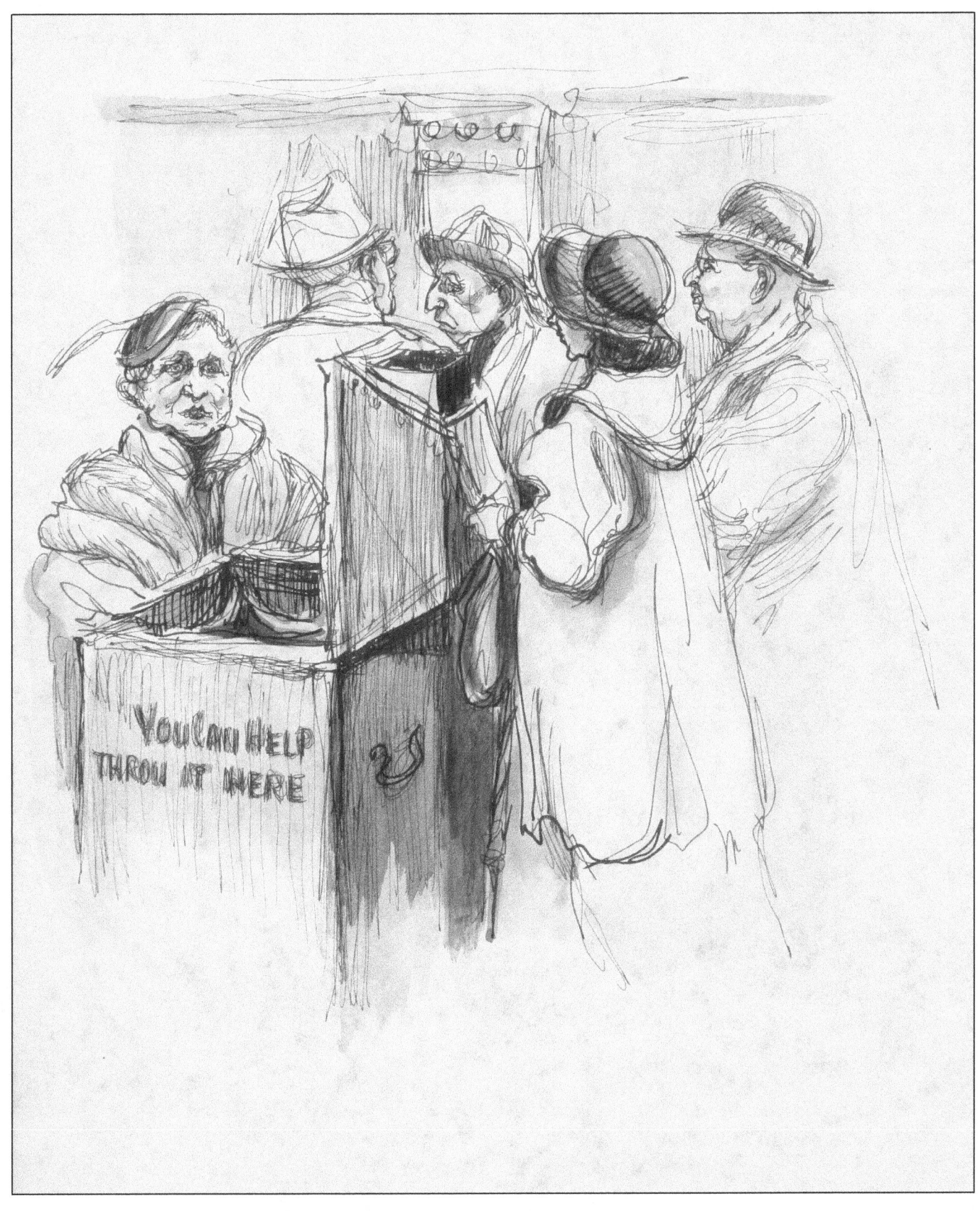

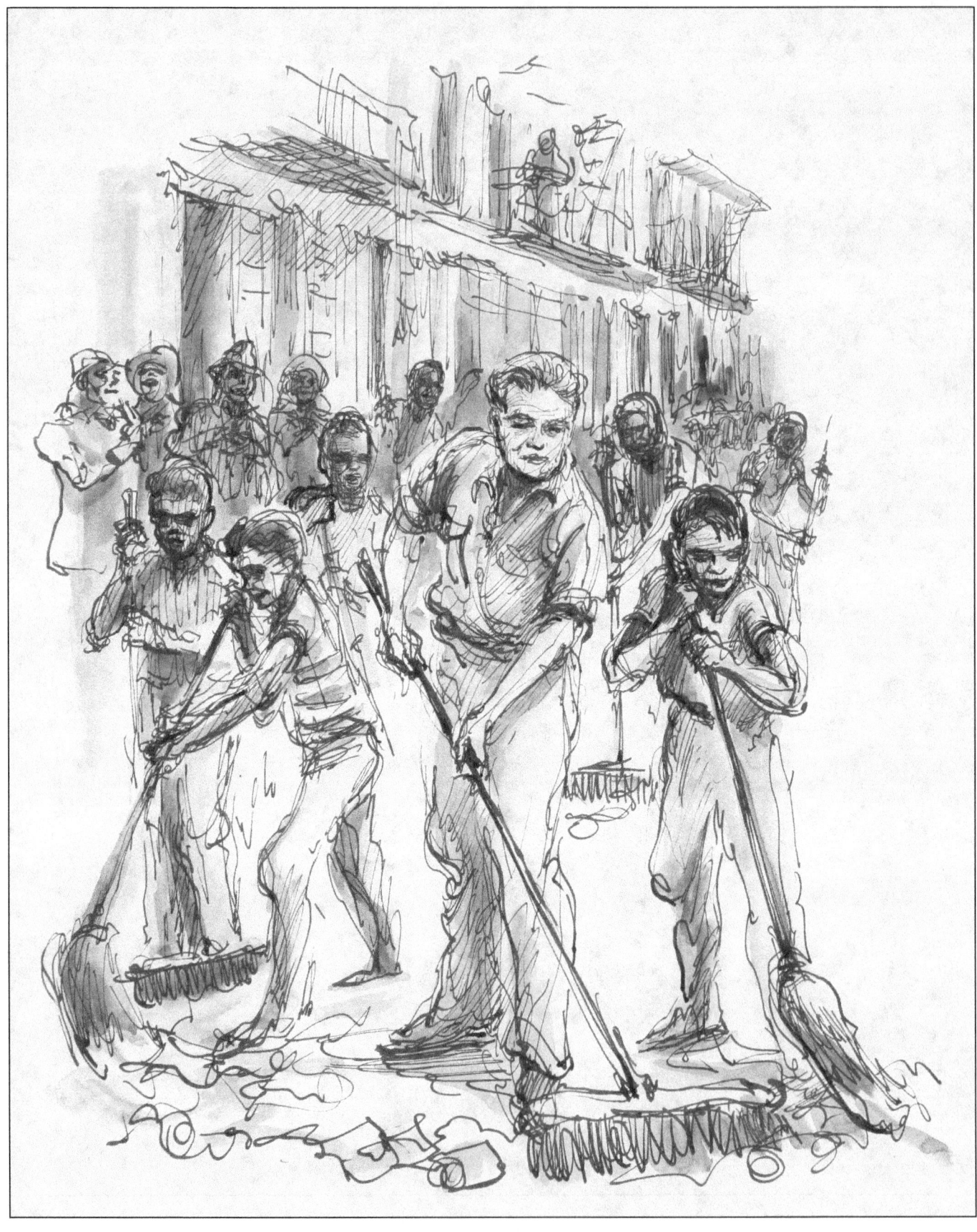

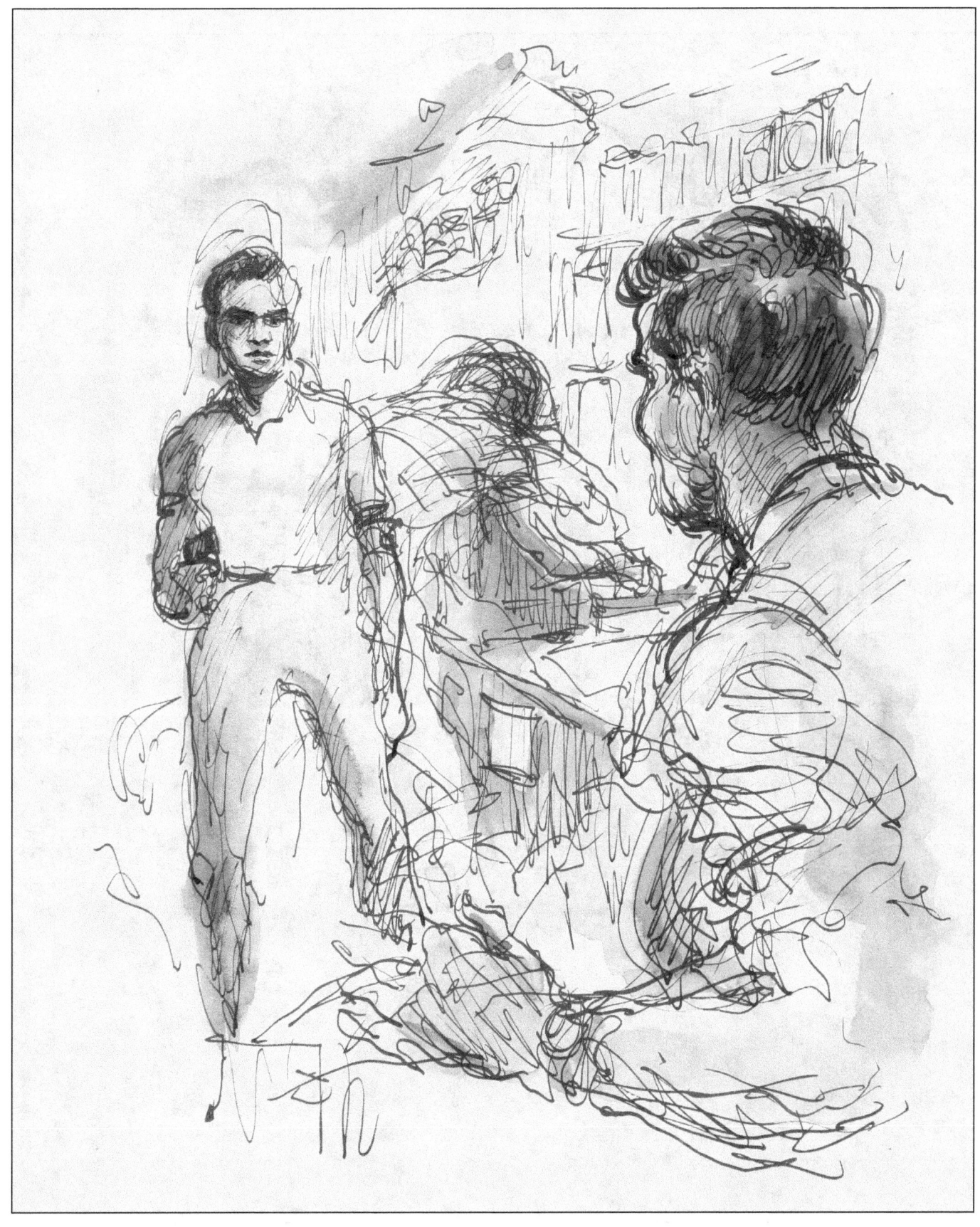

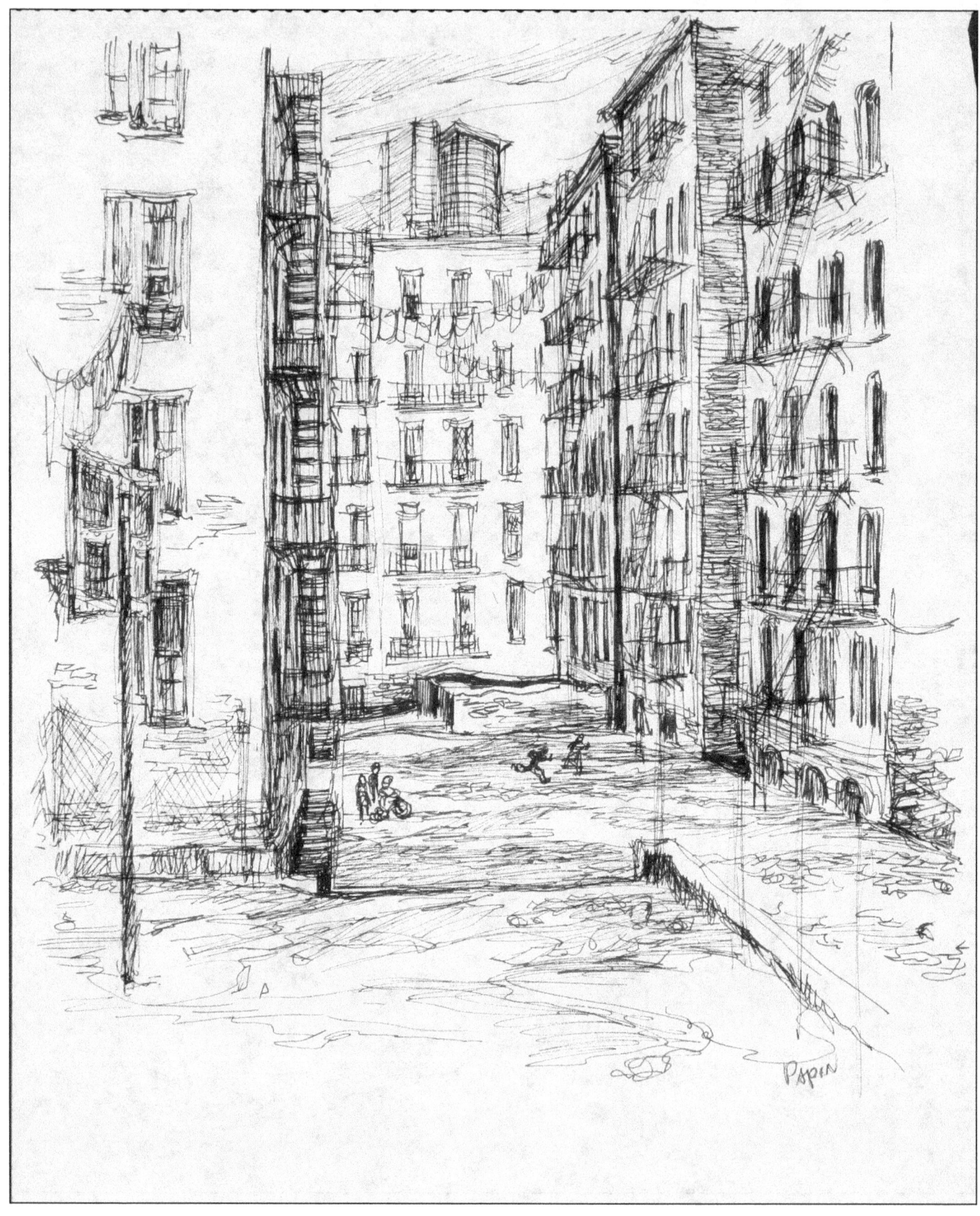

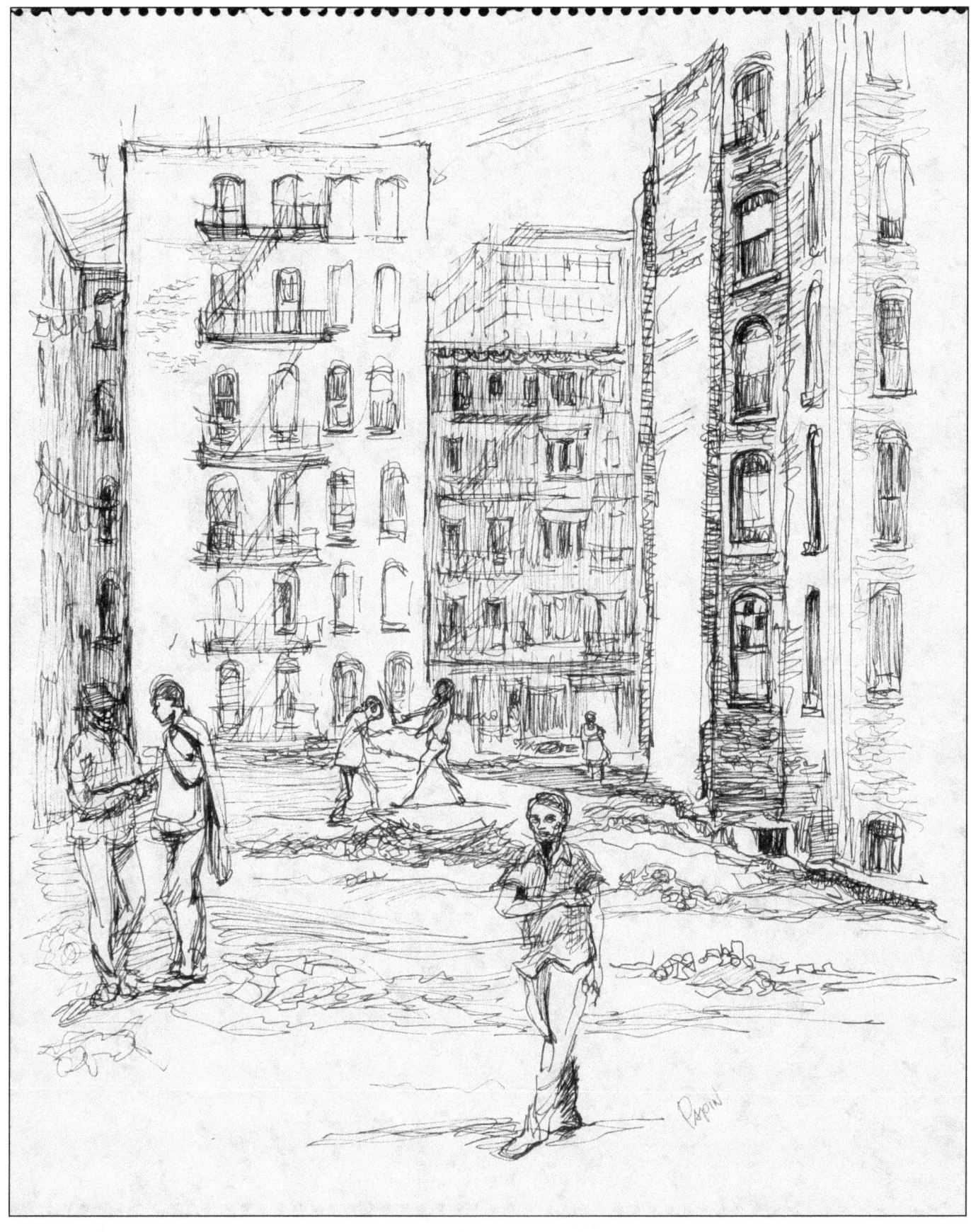

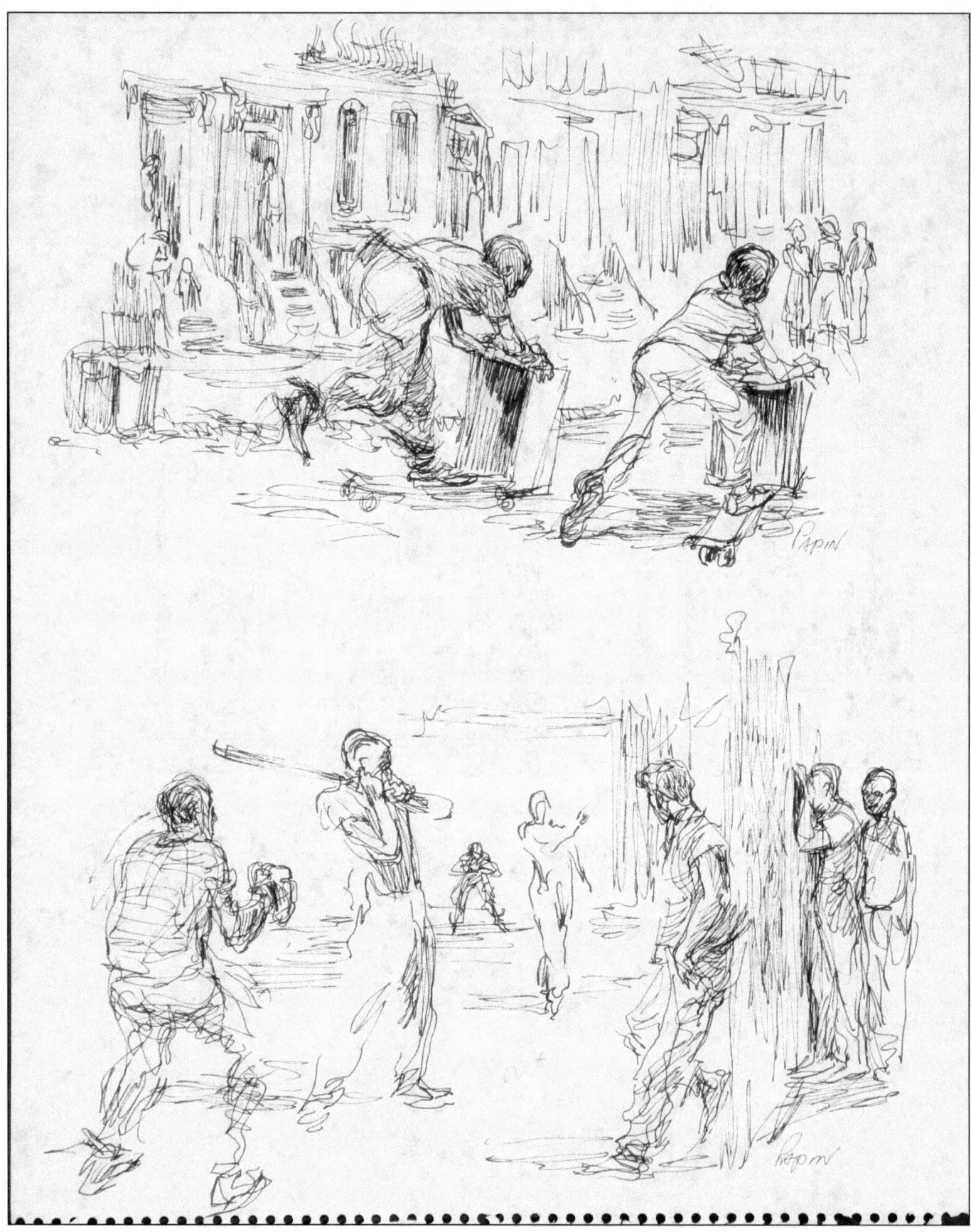

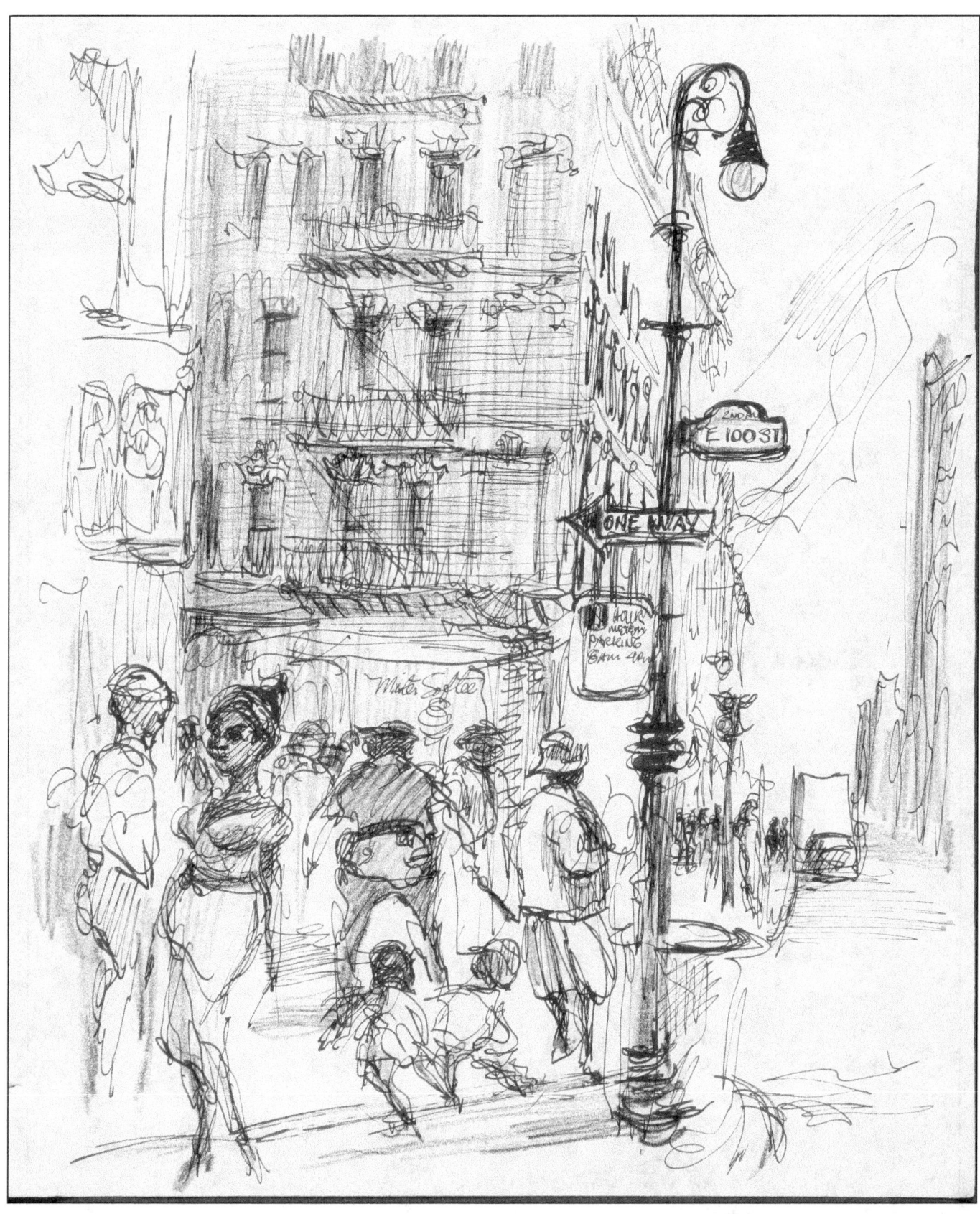

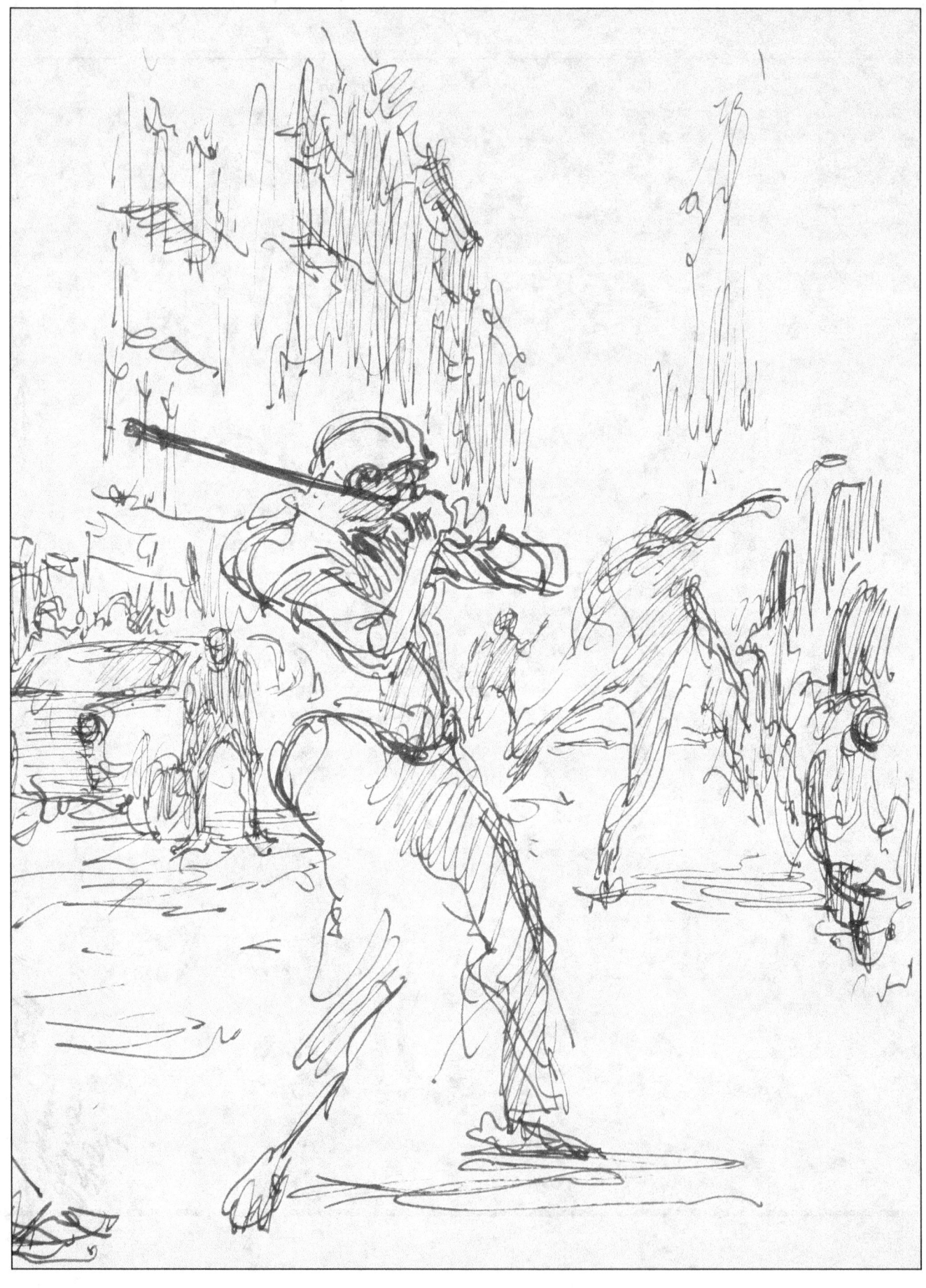

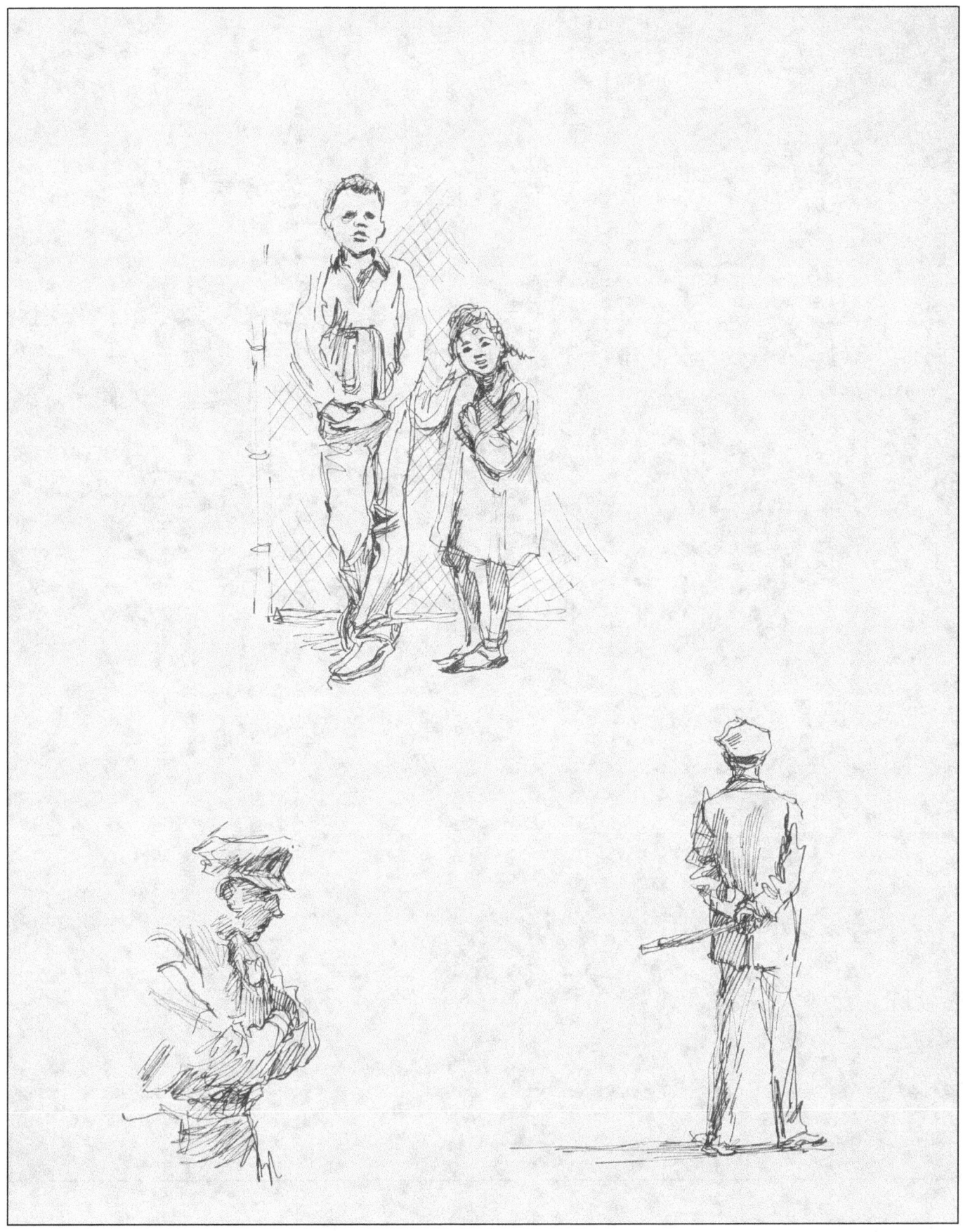

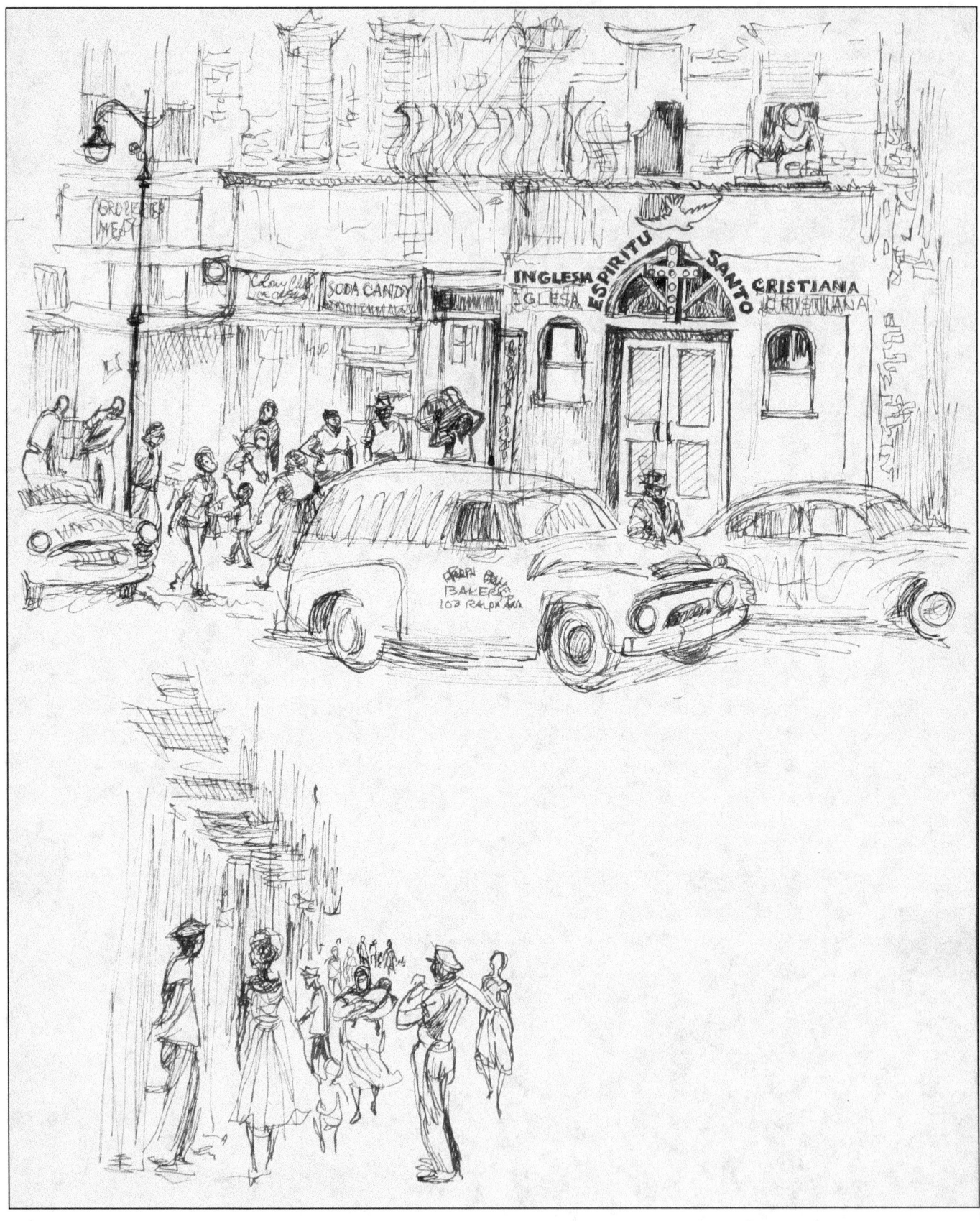

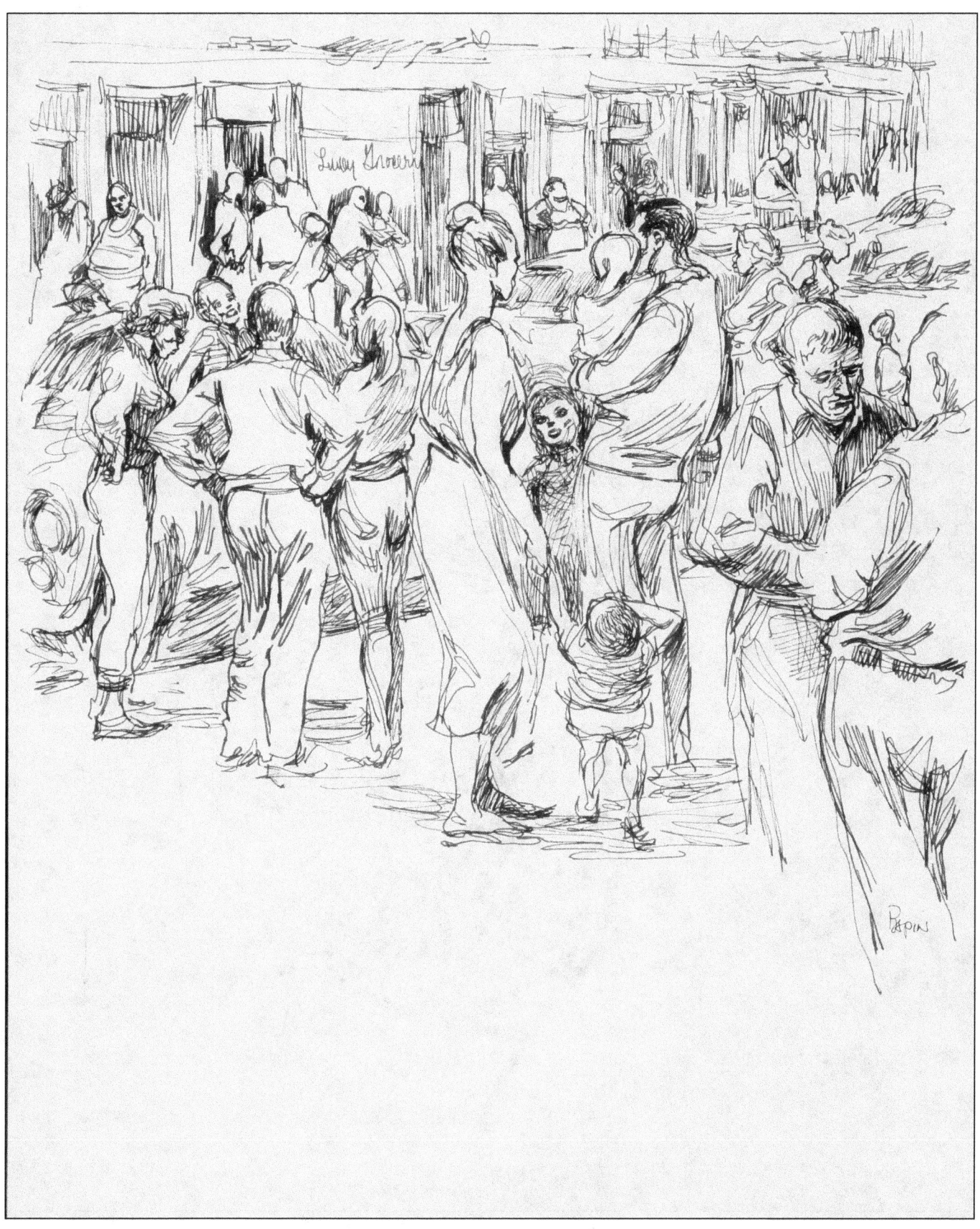

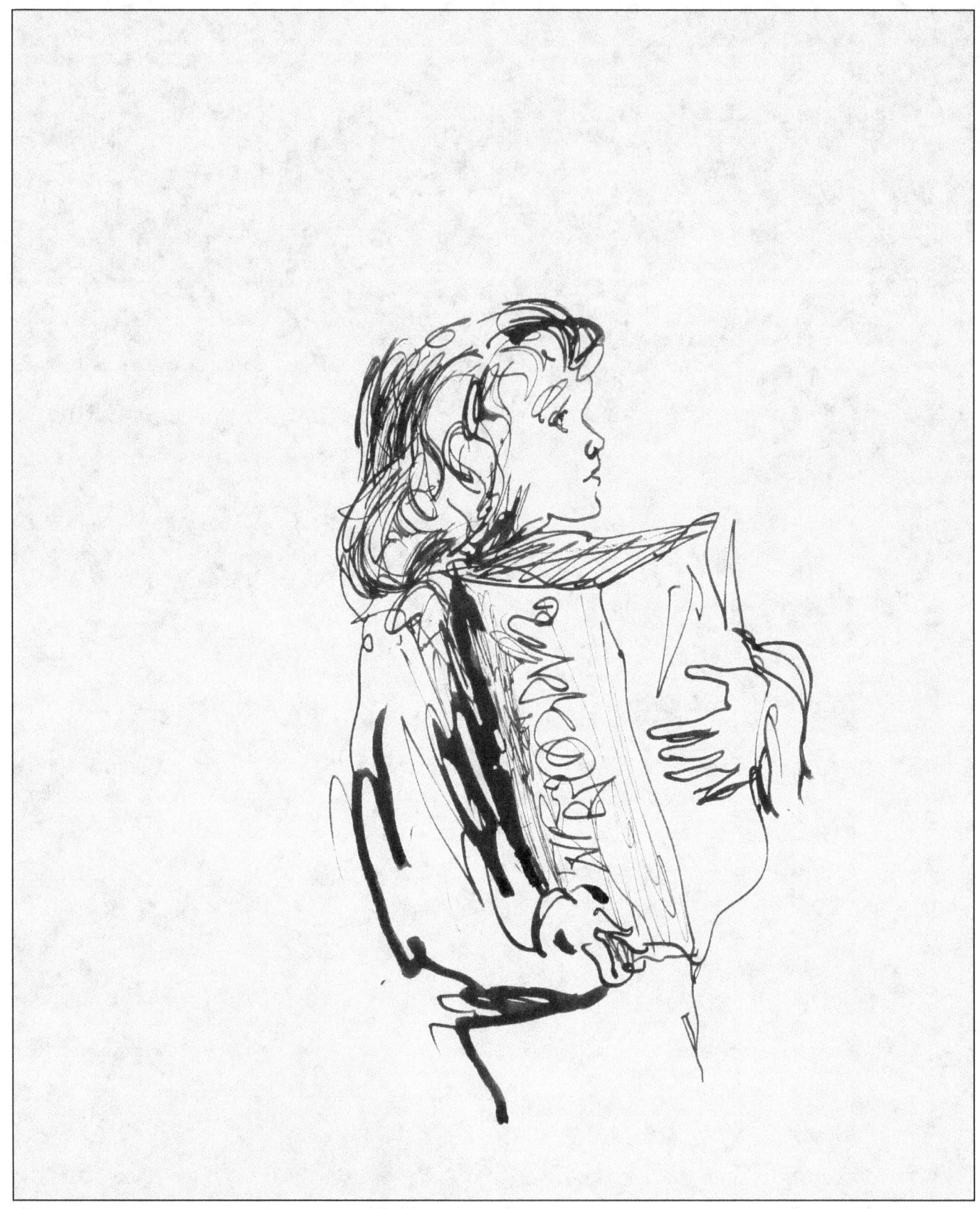

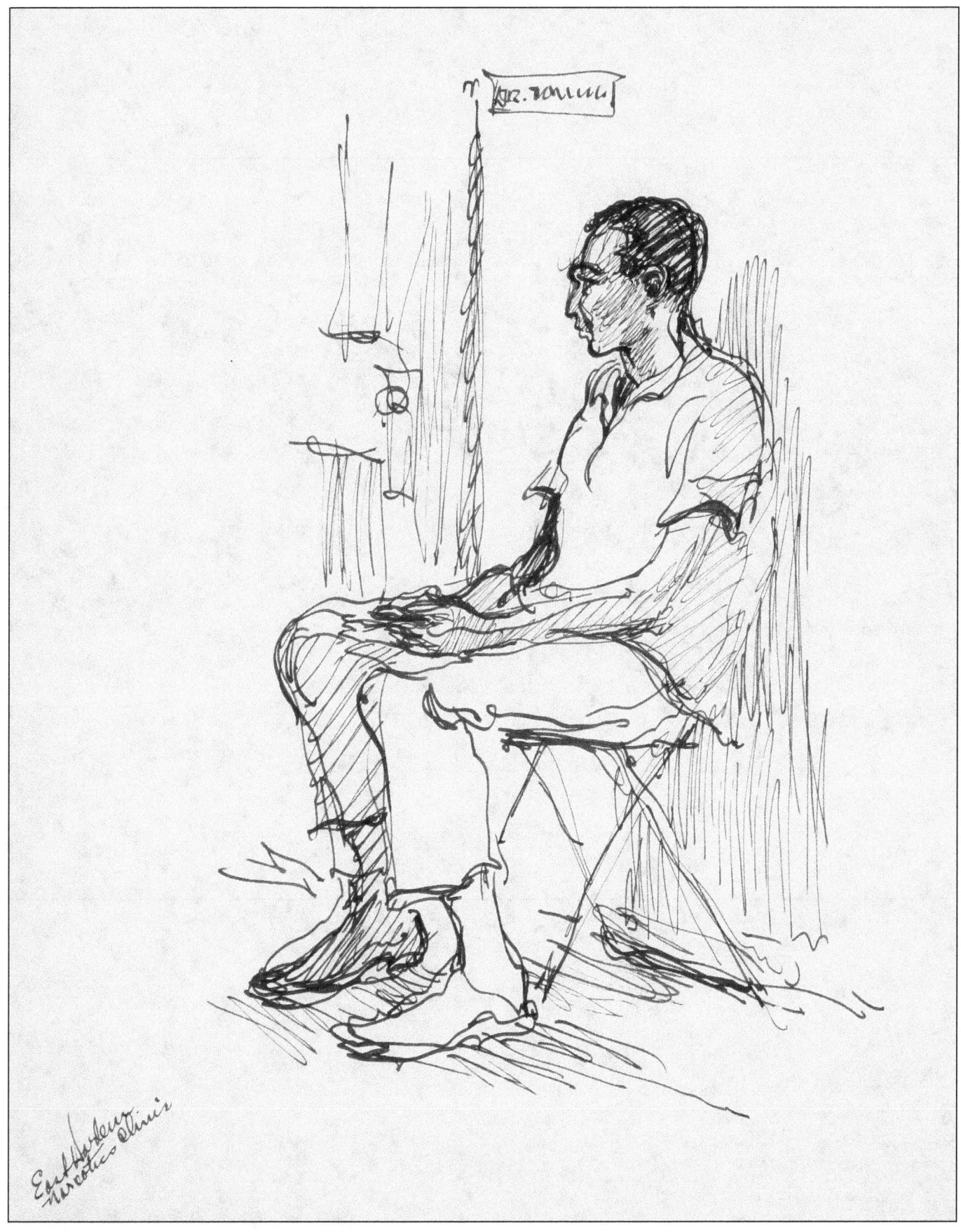

East Harlem Narcotics Clinic

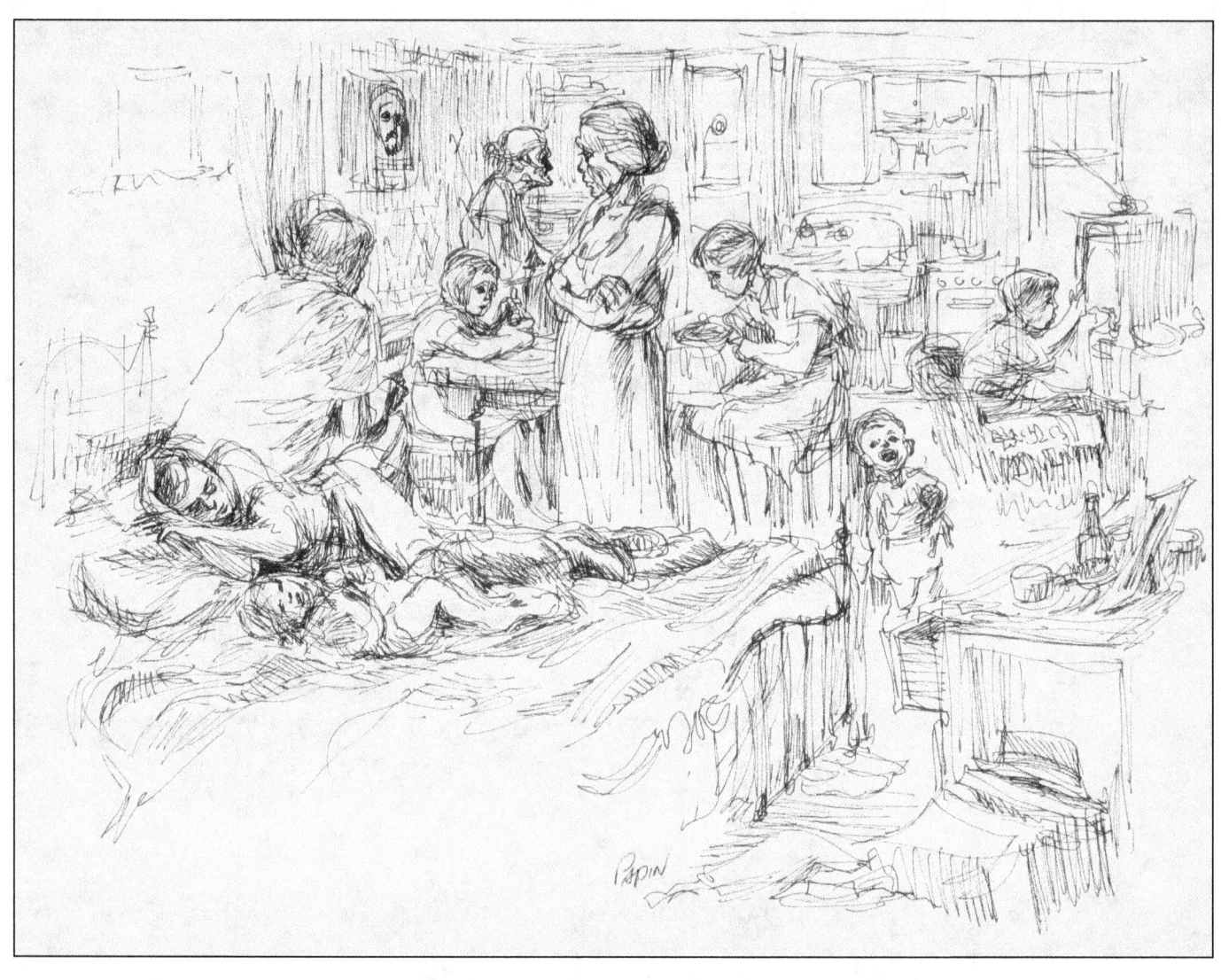

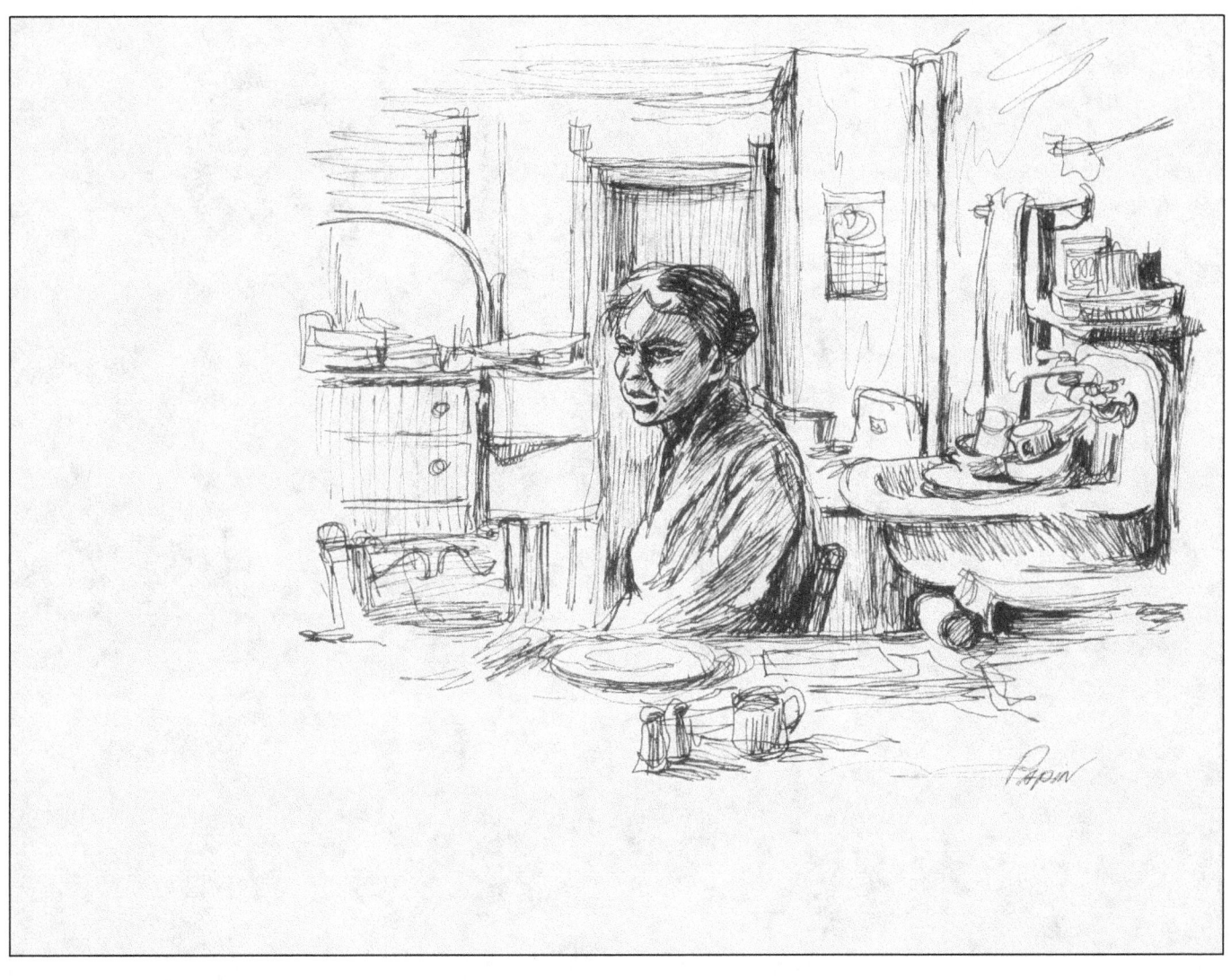

# JOSEPH W. PAPIN

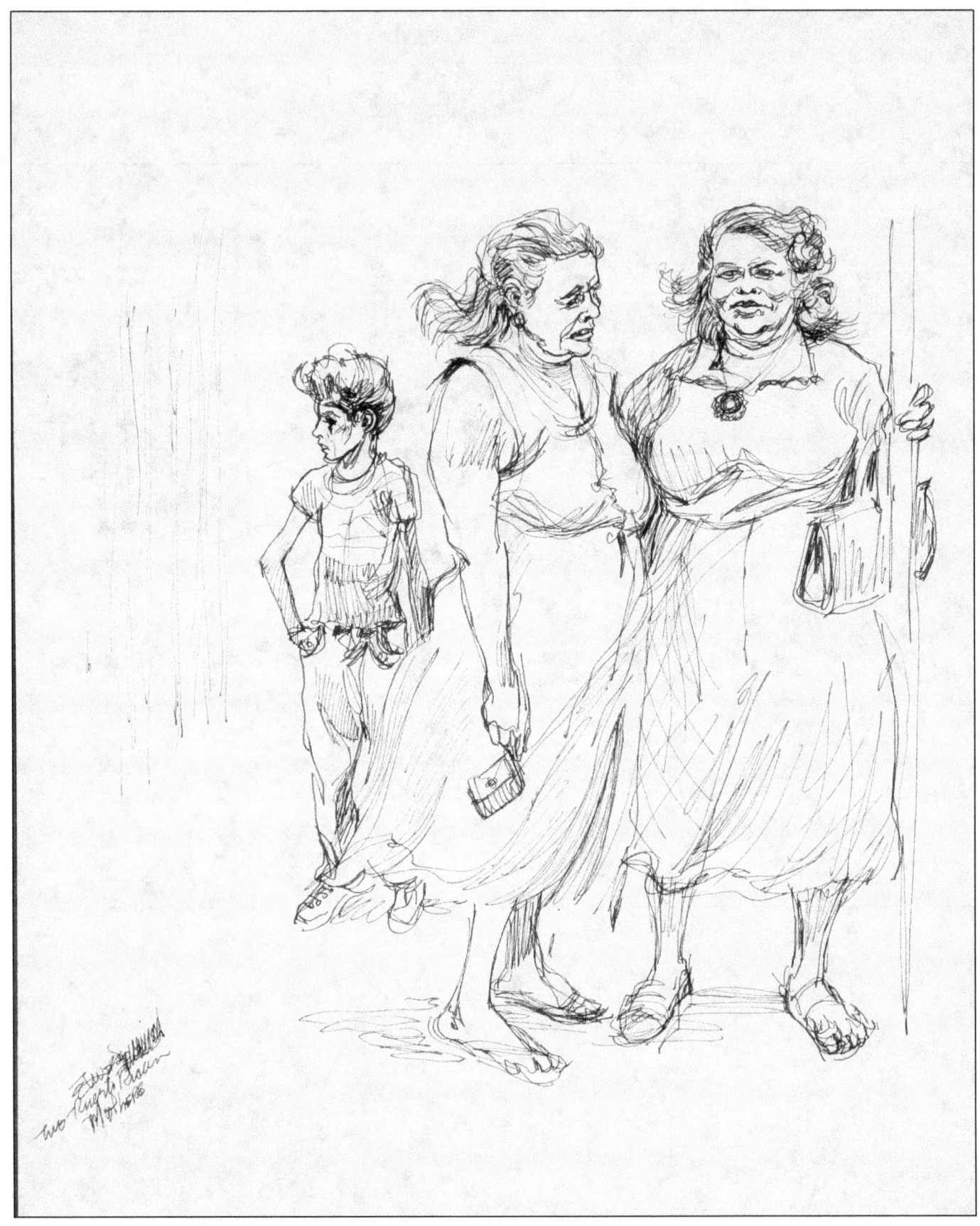

Two Puerto Rican Mothers

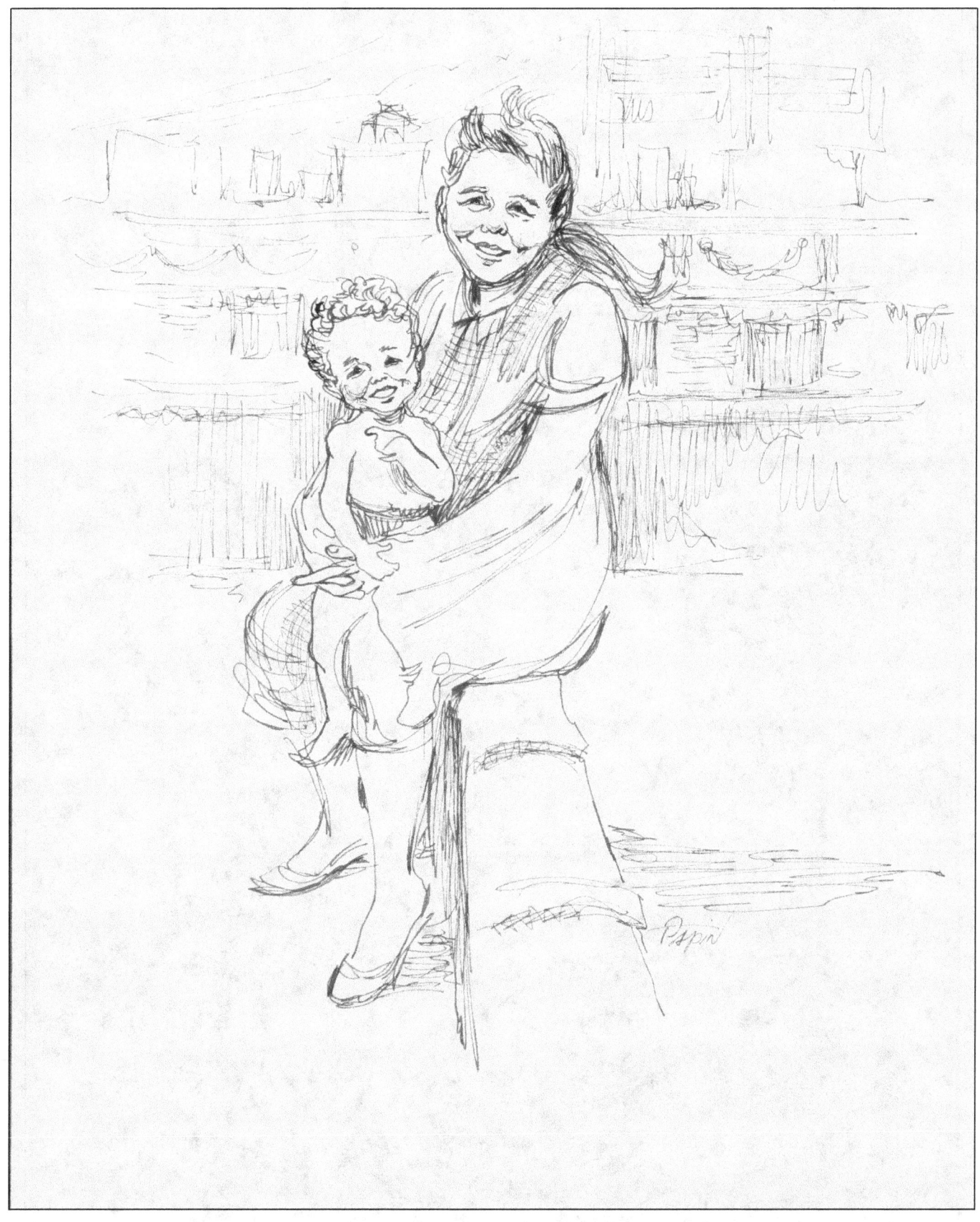

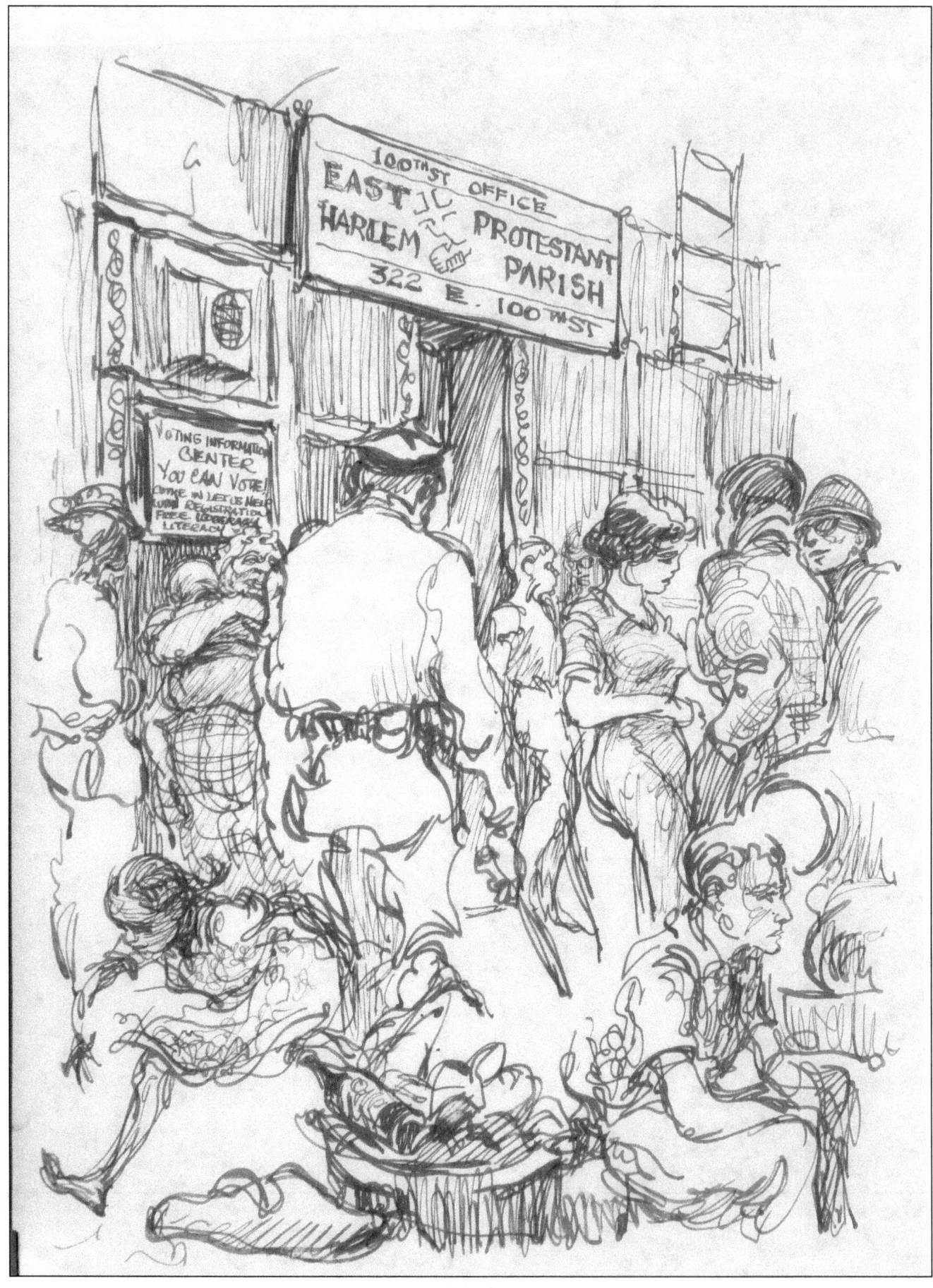

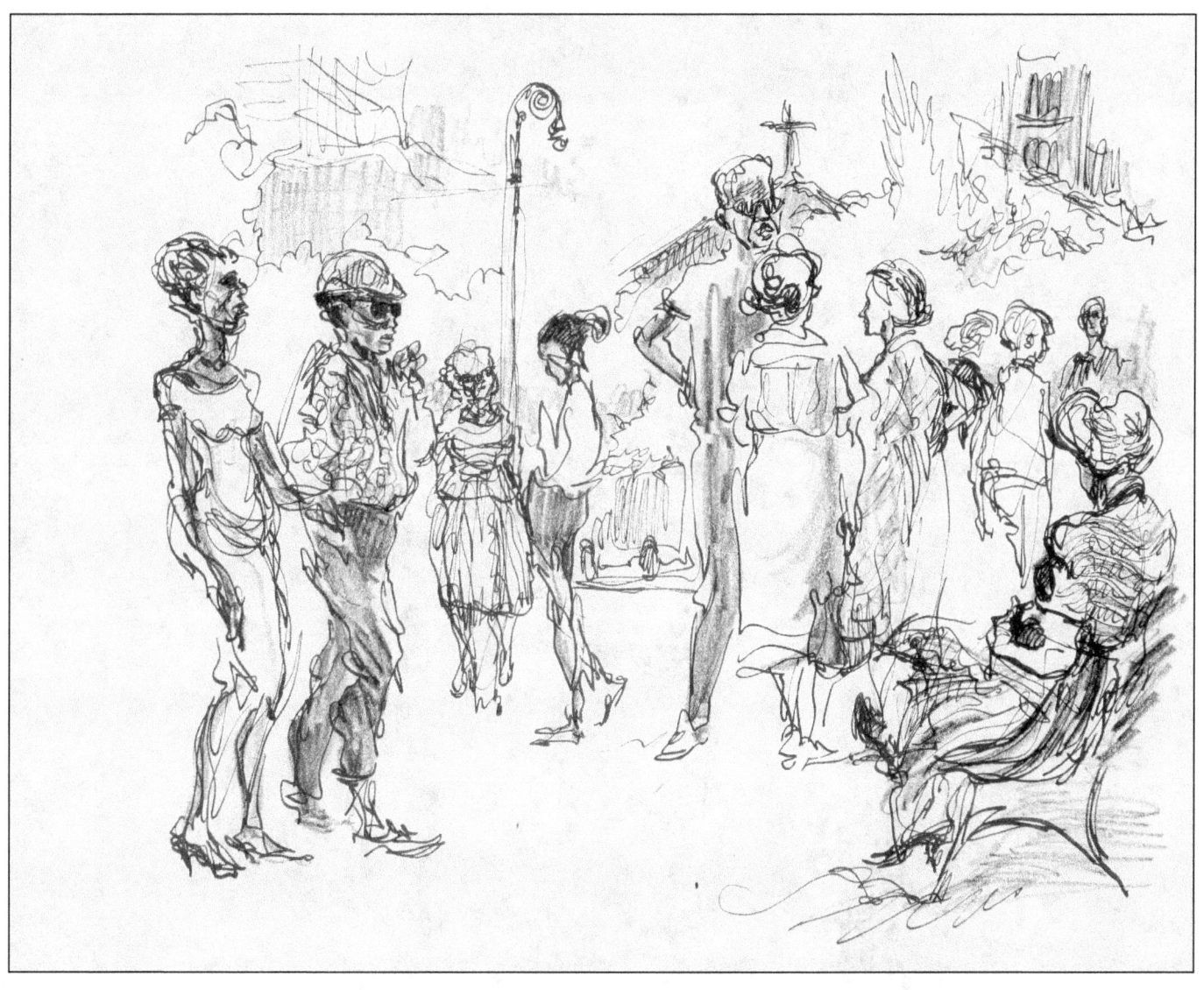

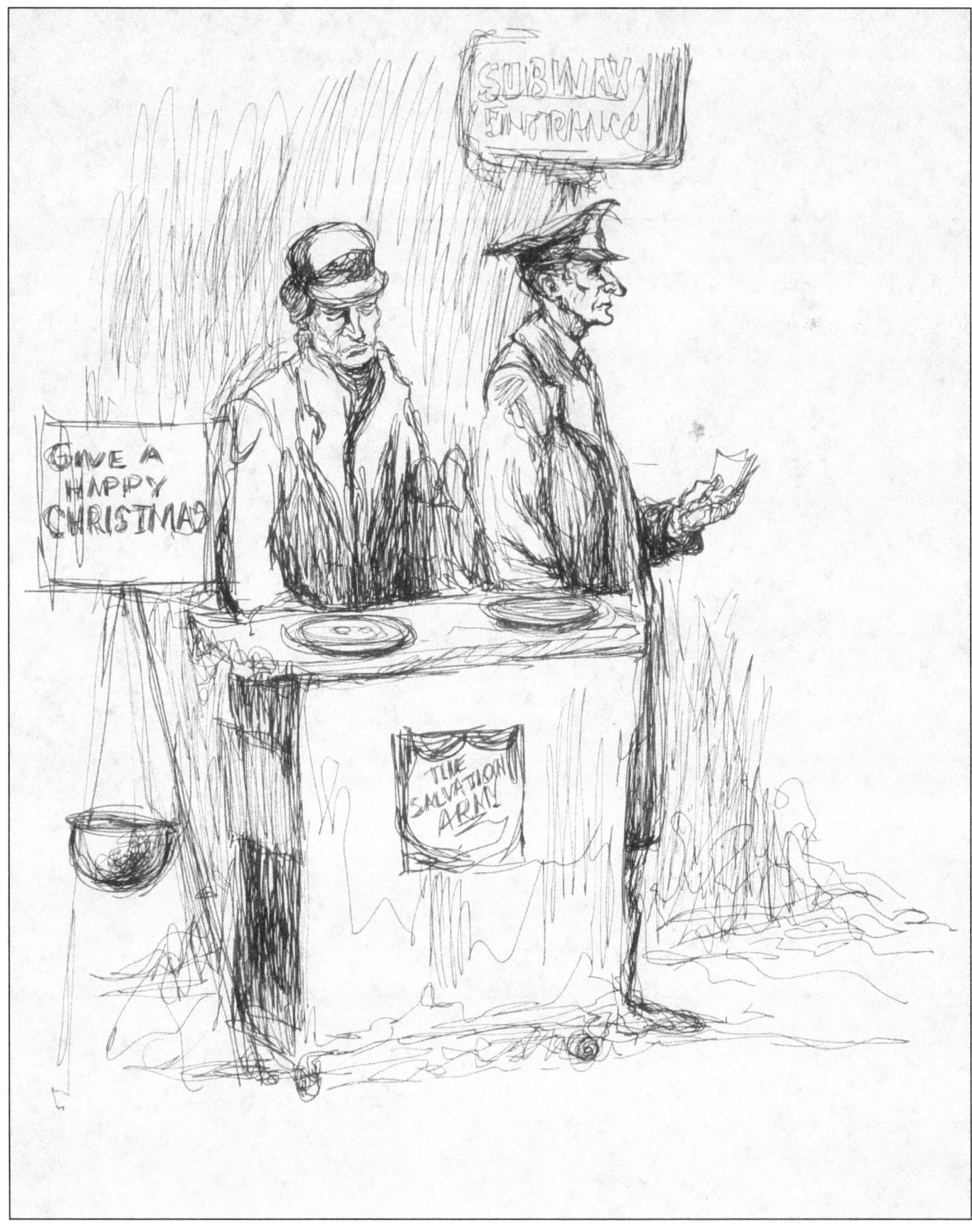

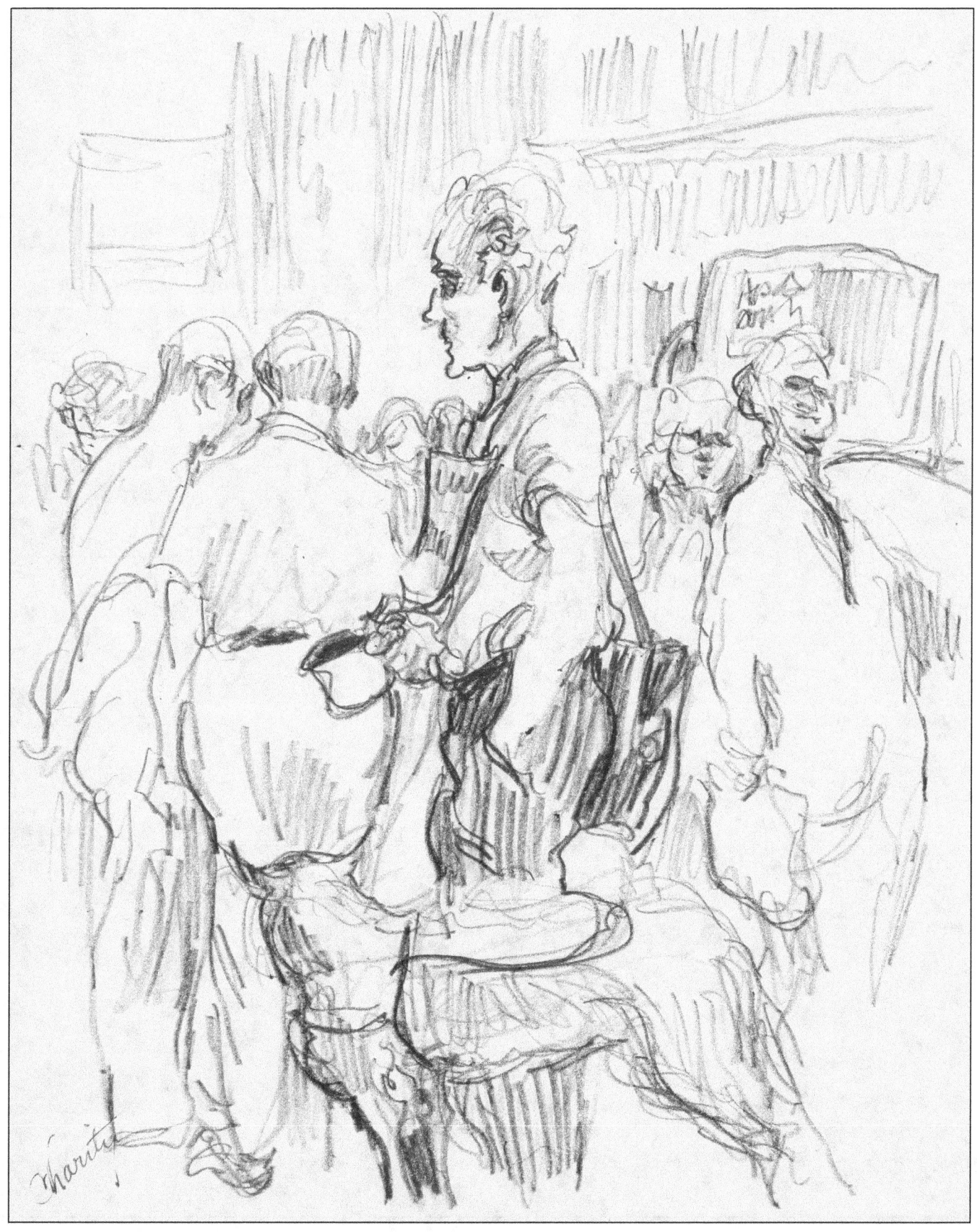
Charity

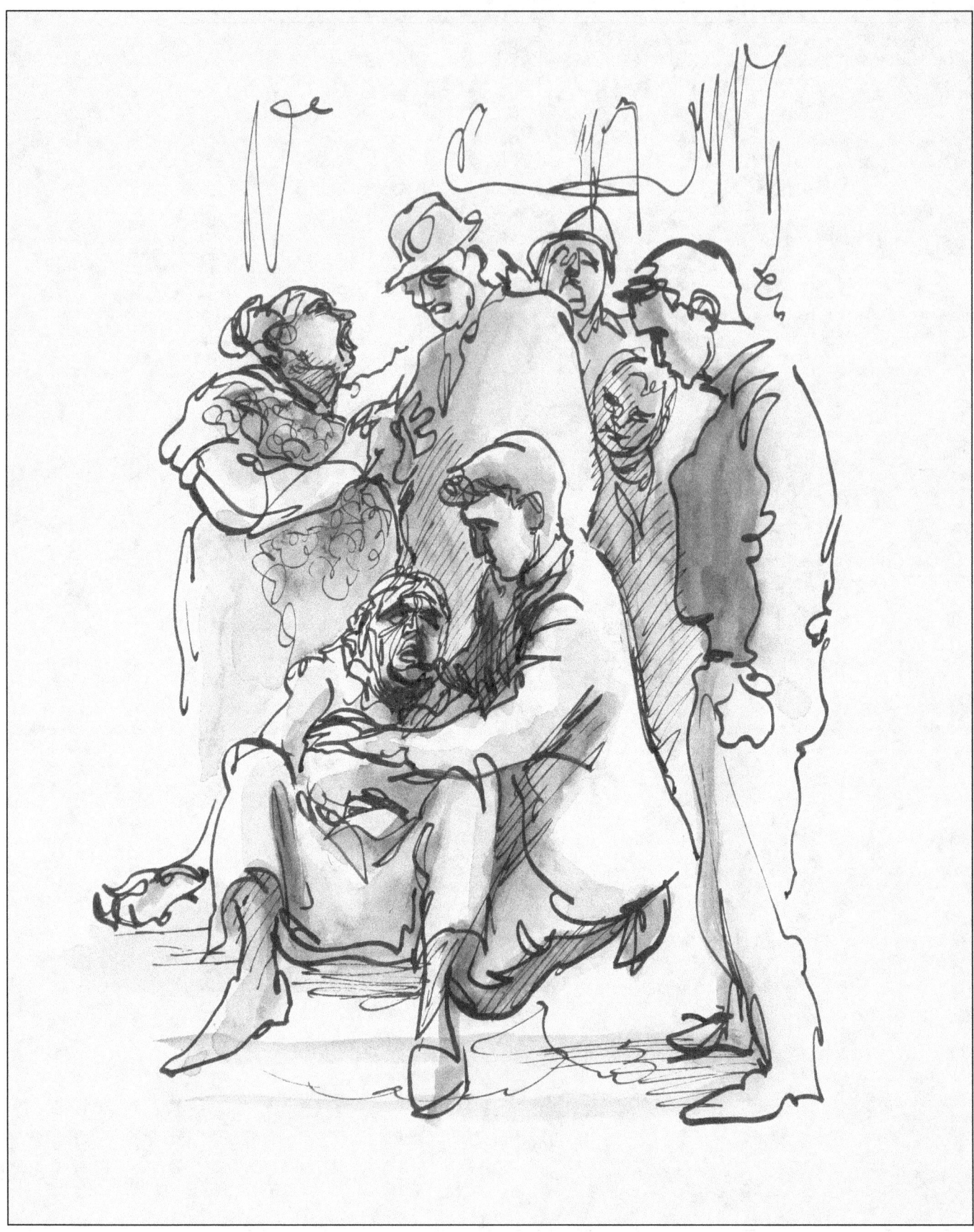

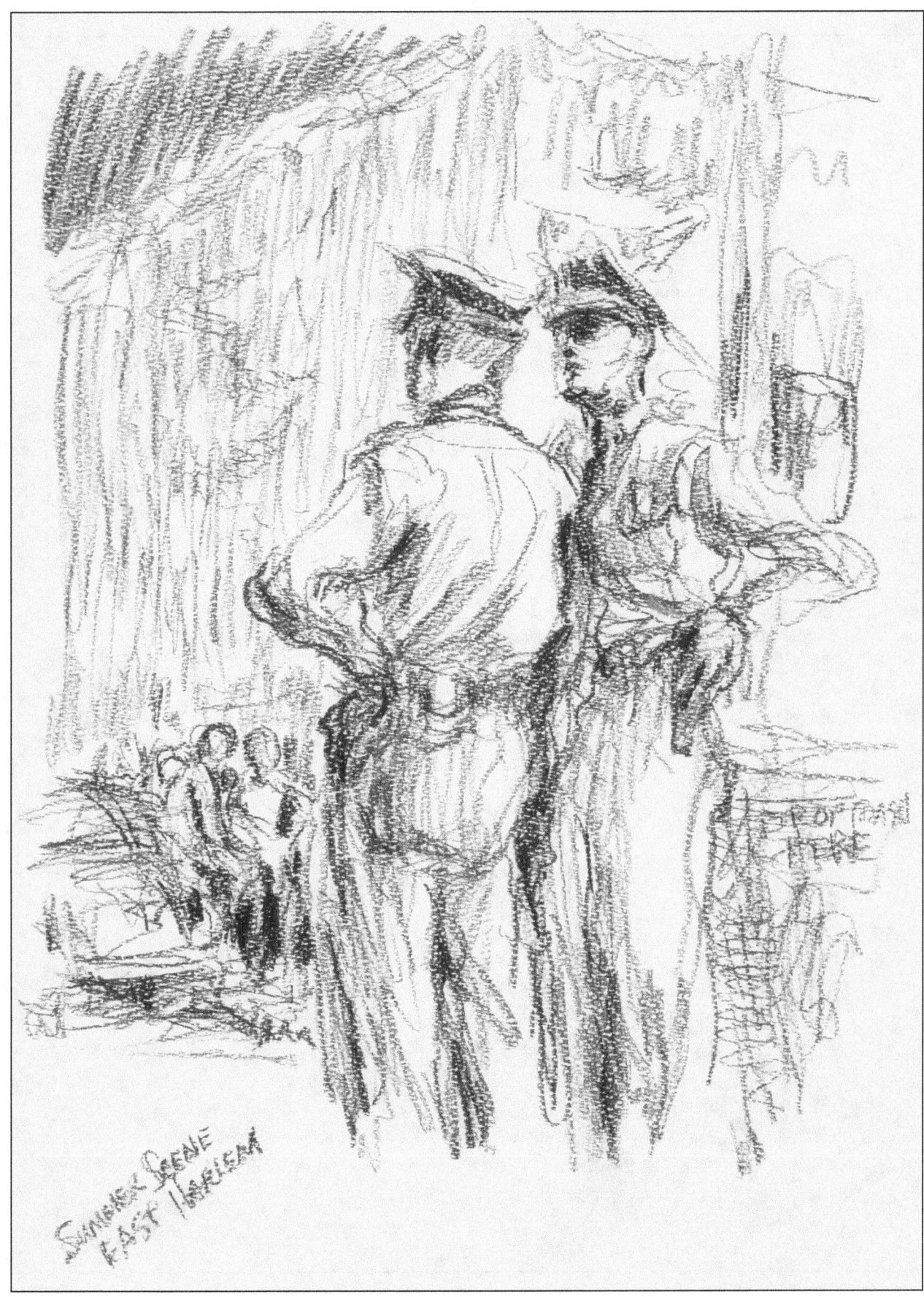

Summer scene East Harlem

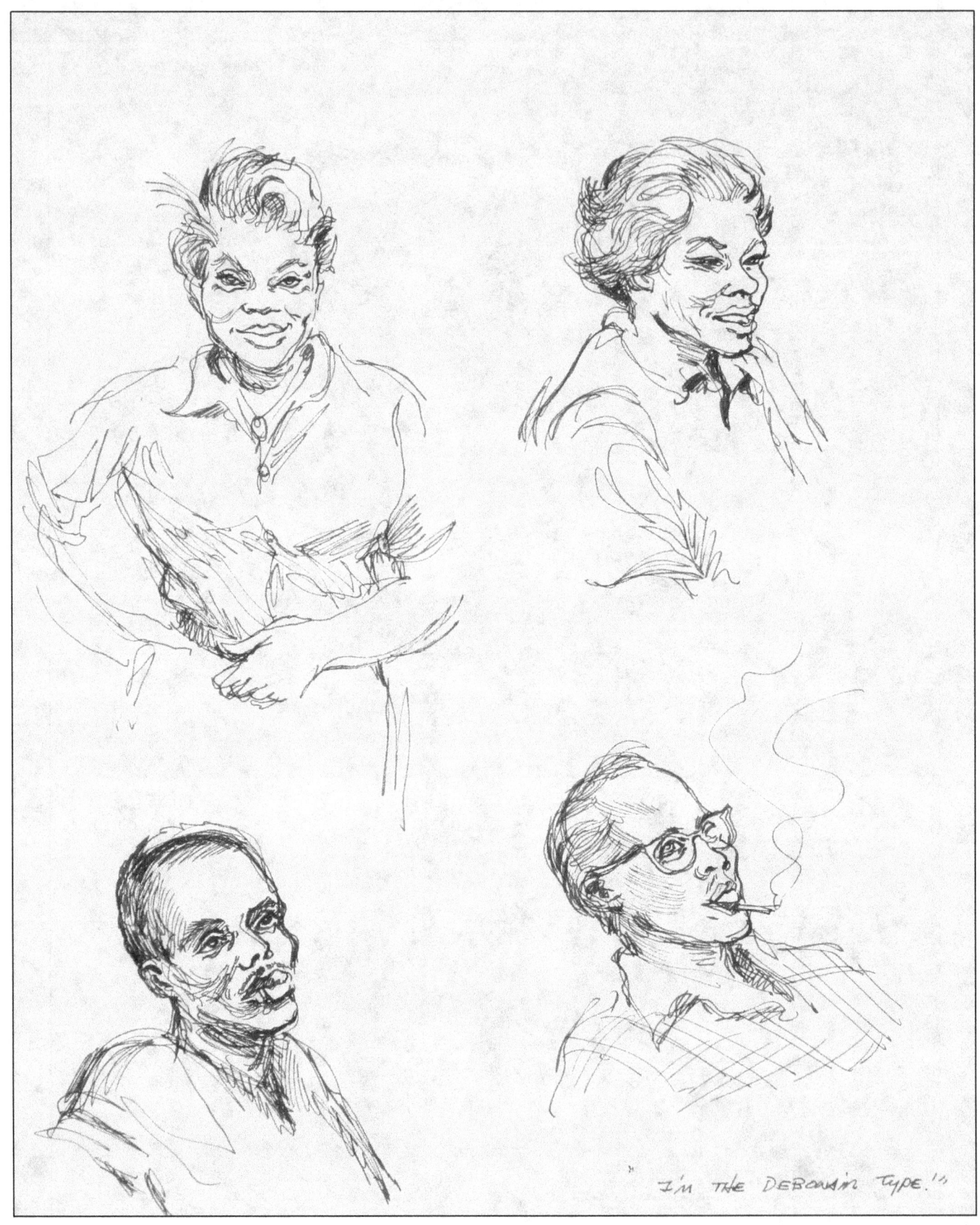

"I'm the debonair type."

# THE STREET IS MY STUDIO: EAST HARLEM PROTESTANT PARISH

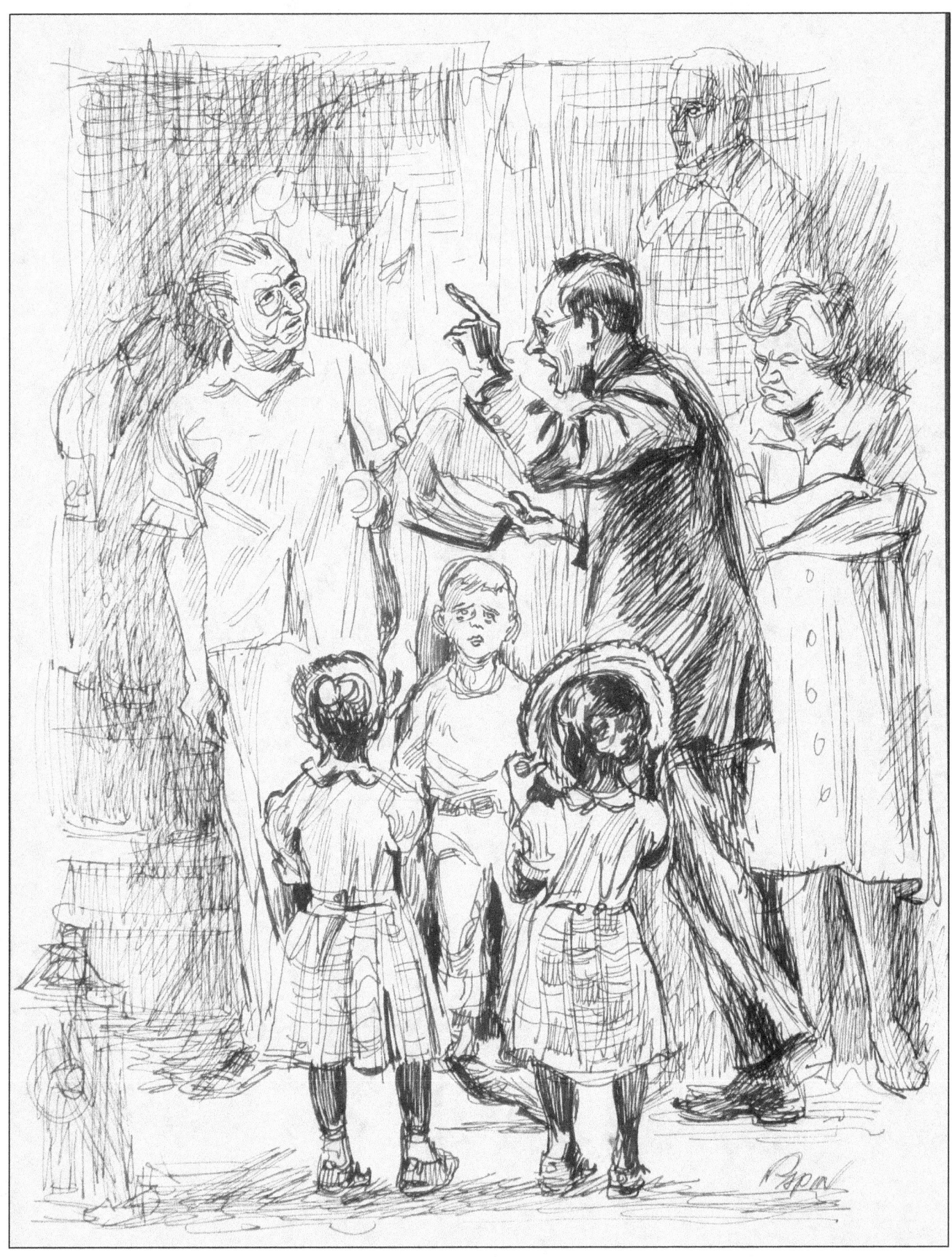

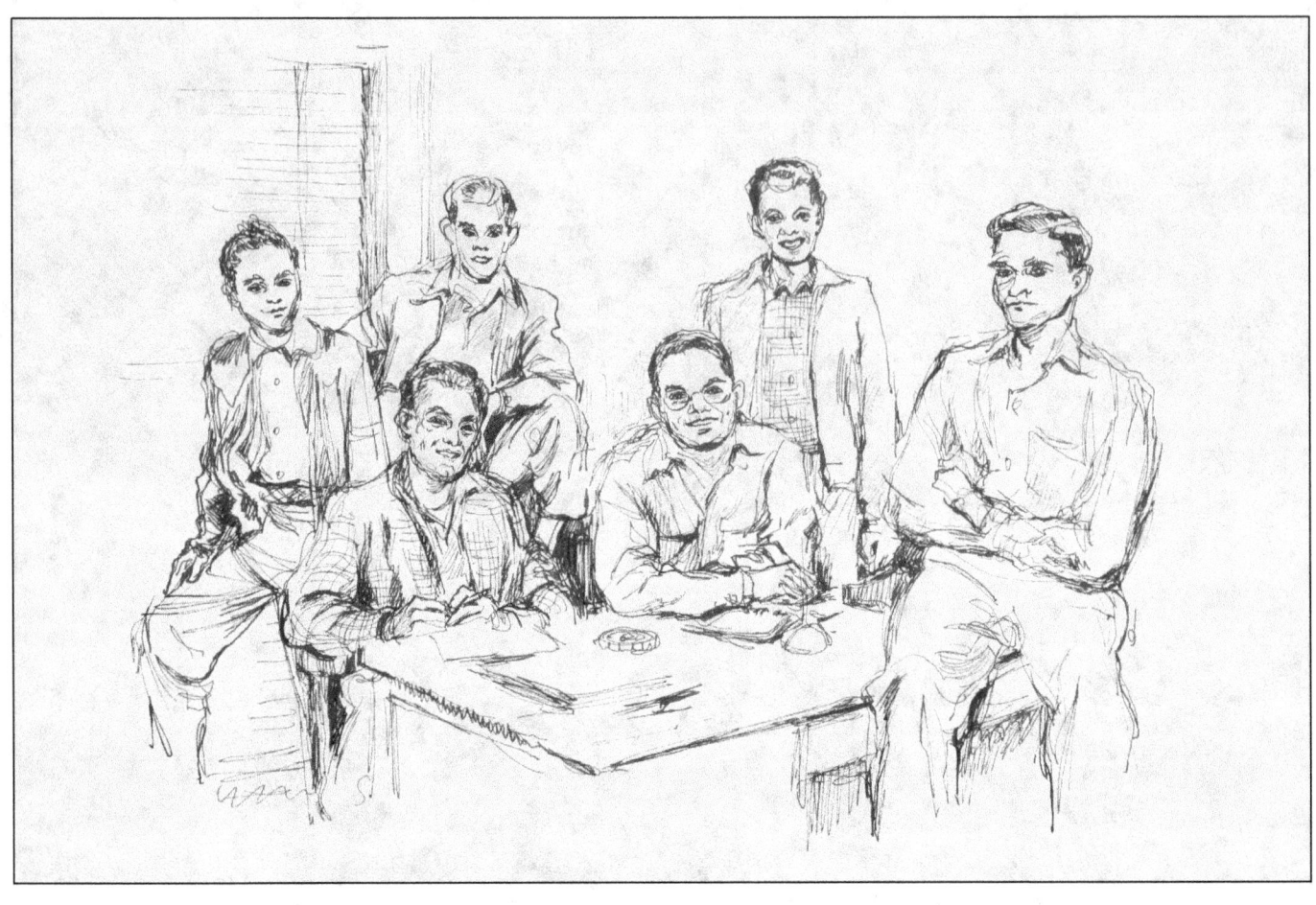

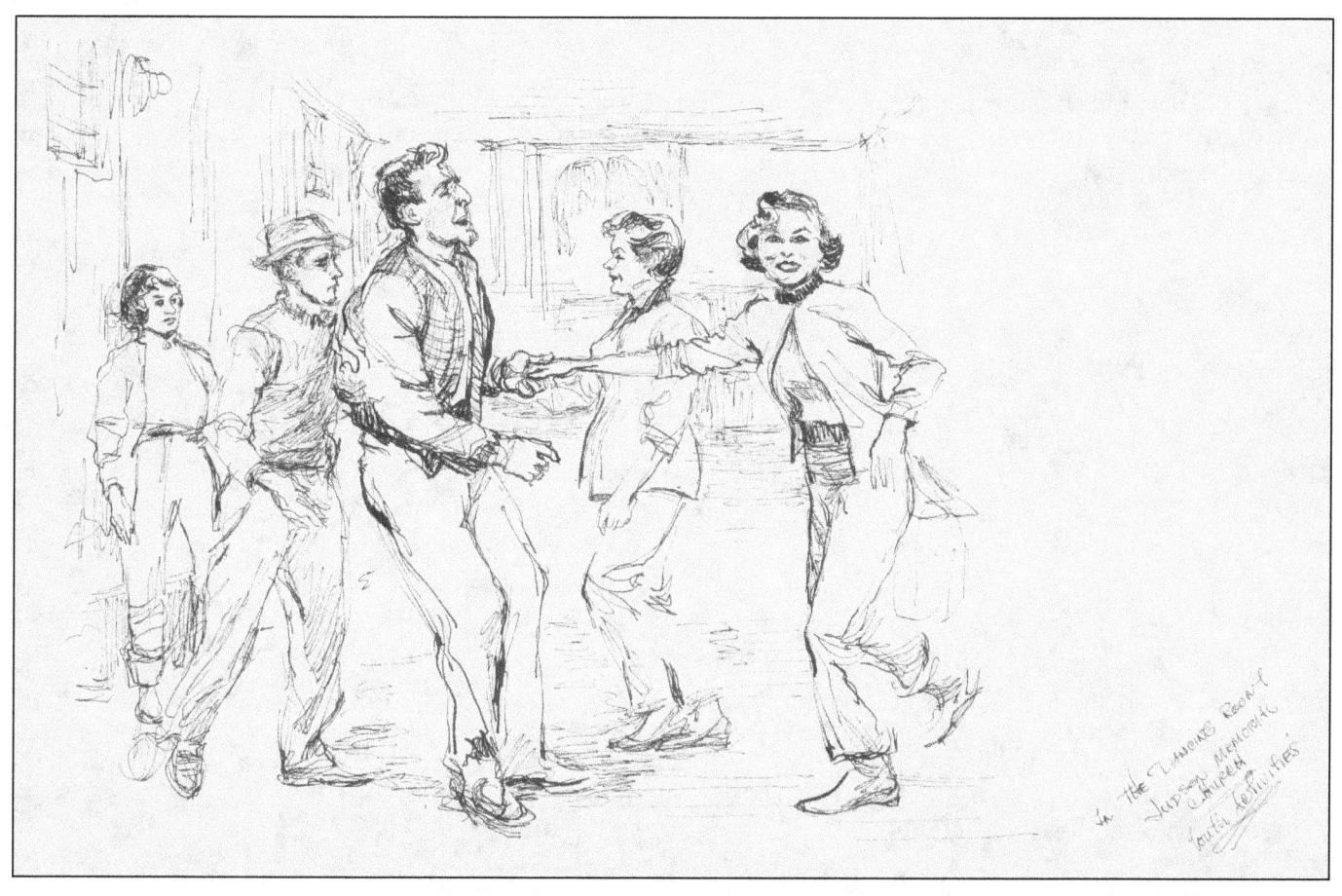
In the dancing room at Judson Memorial Church, youth activities

# JOSEPH W. PAPIN

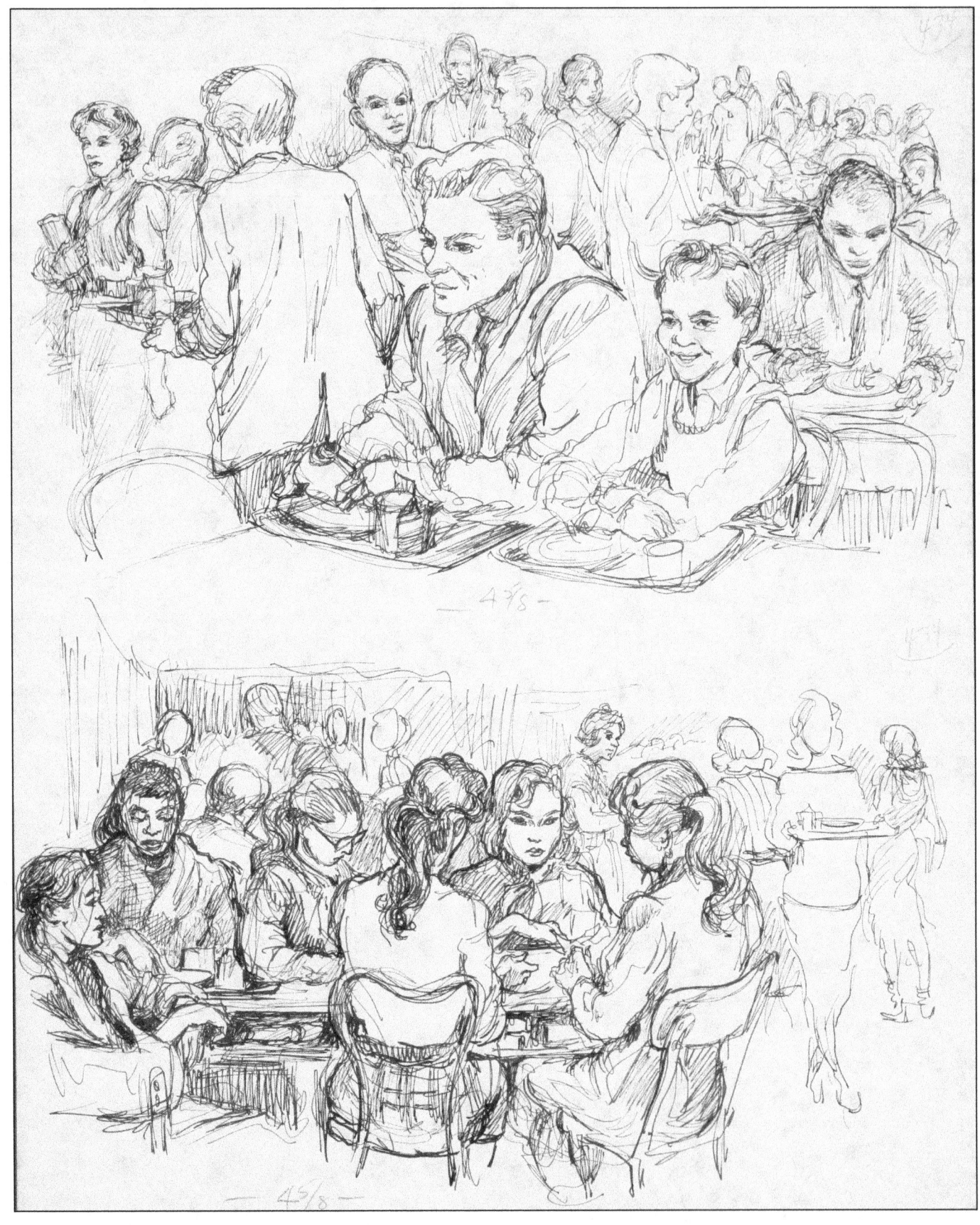

# THE STREET IS MY STUDIO: EAST HARLEM PROTESTANT PARISH

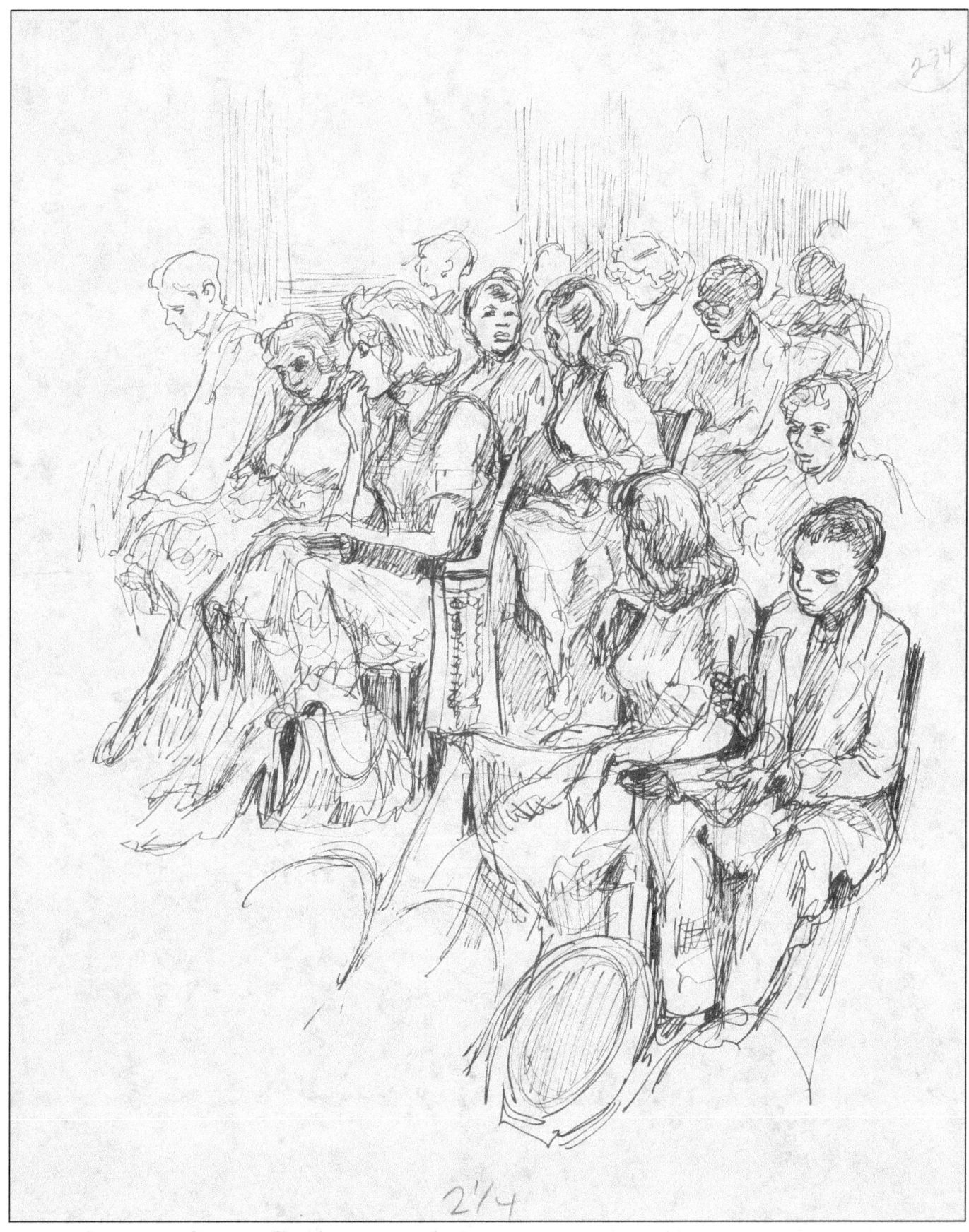

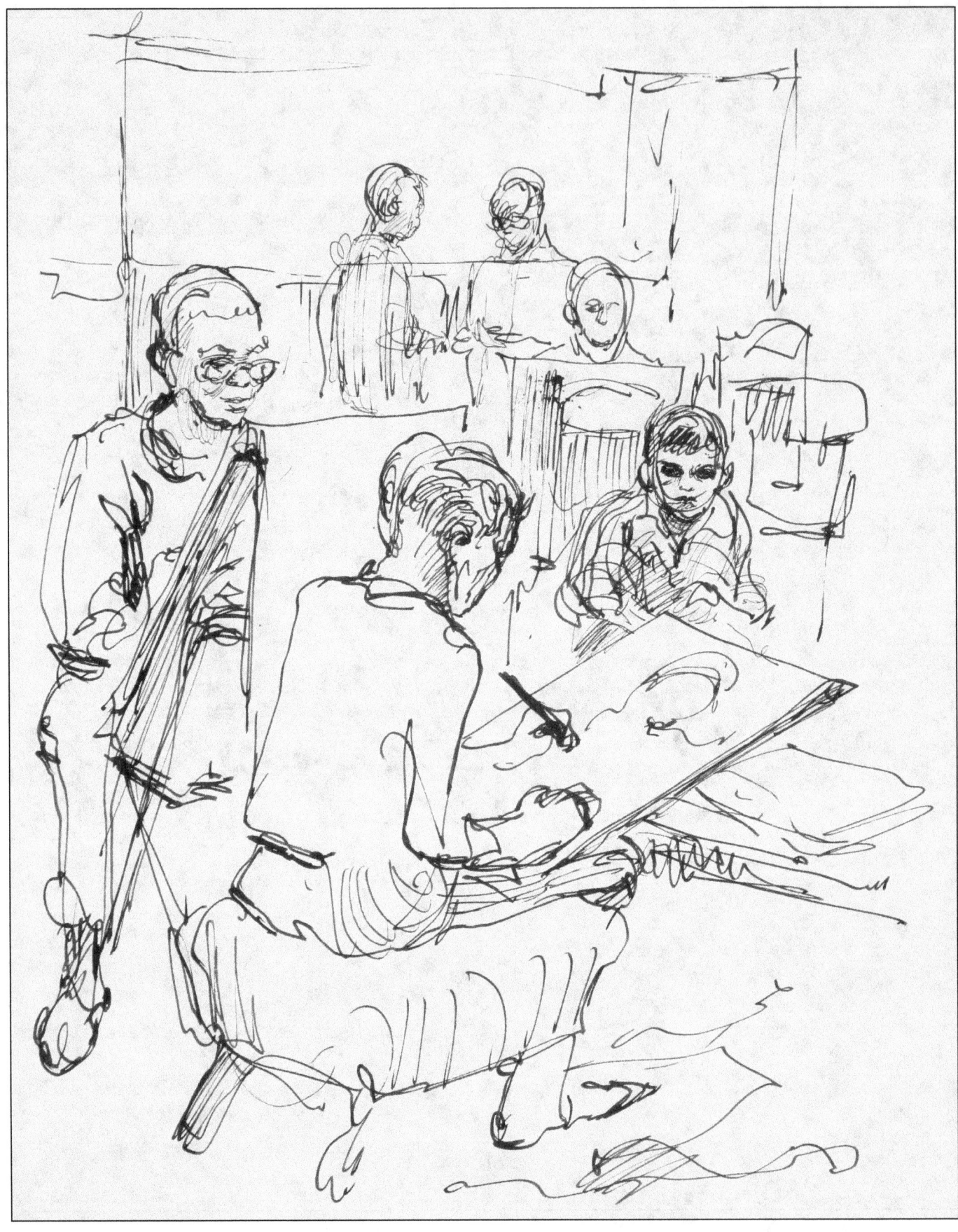

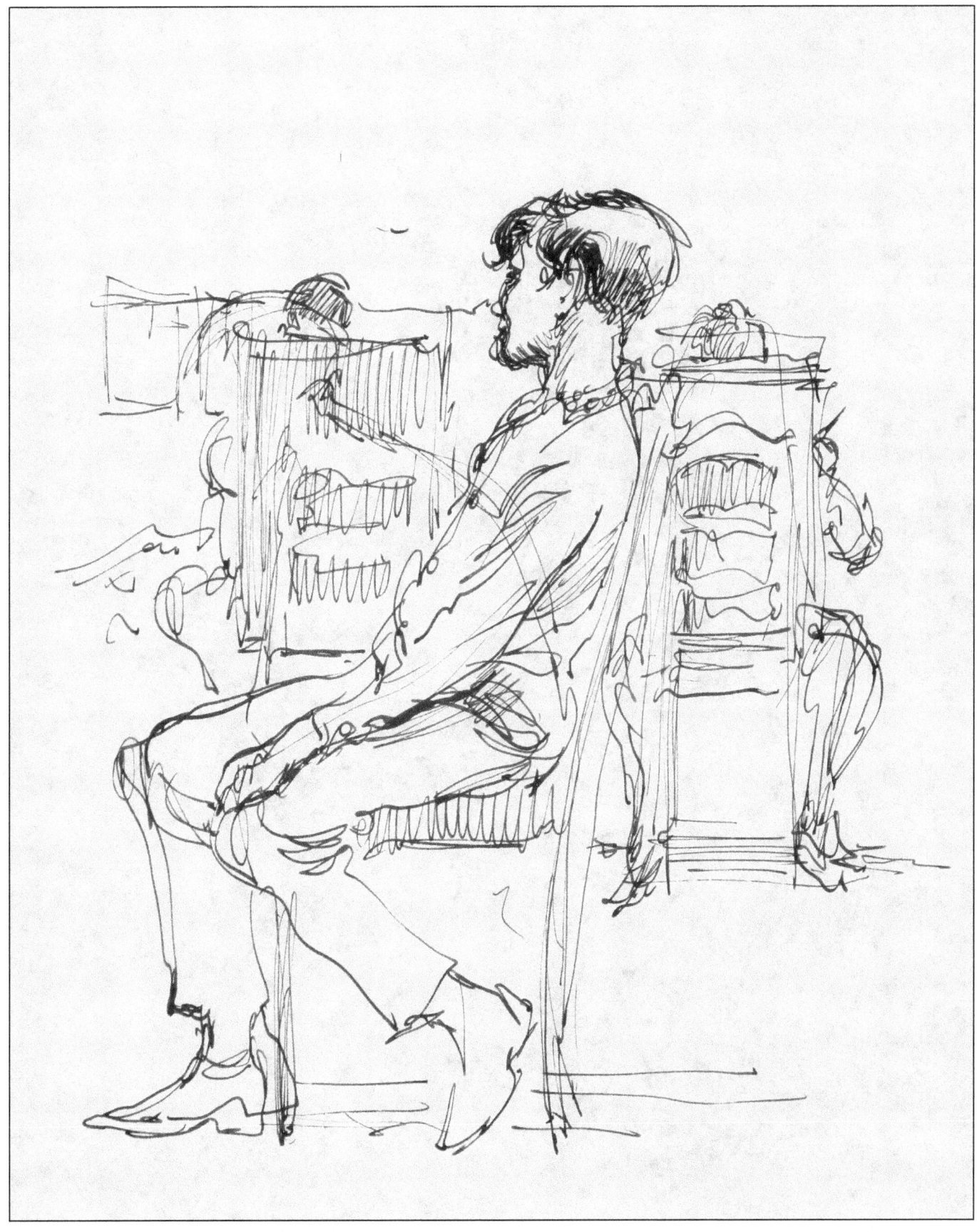

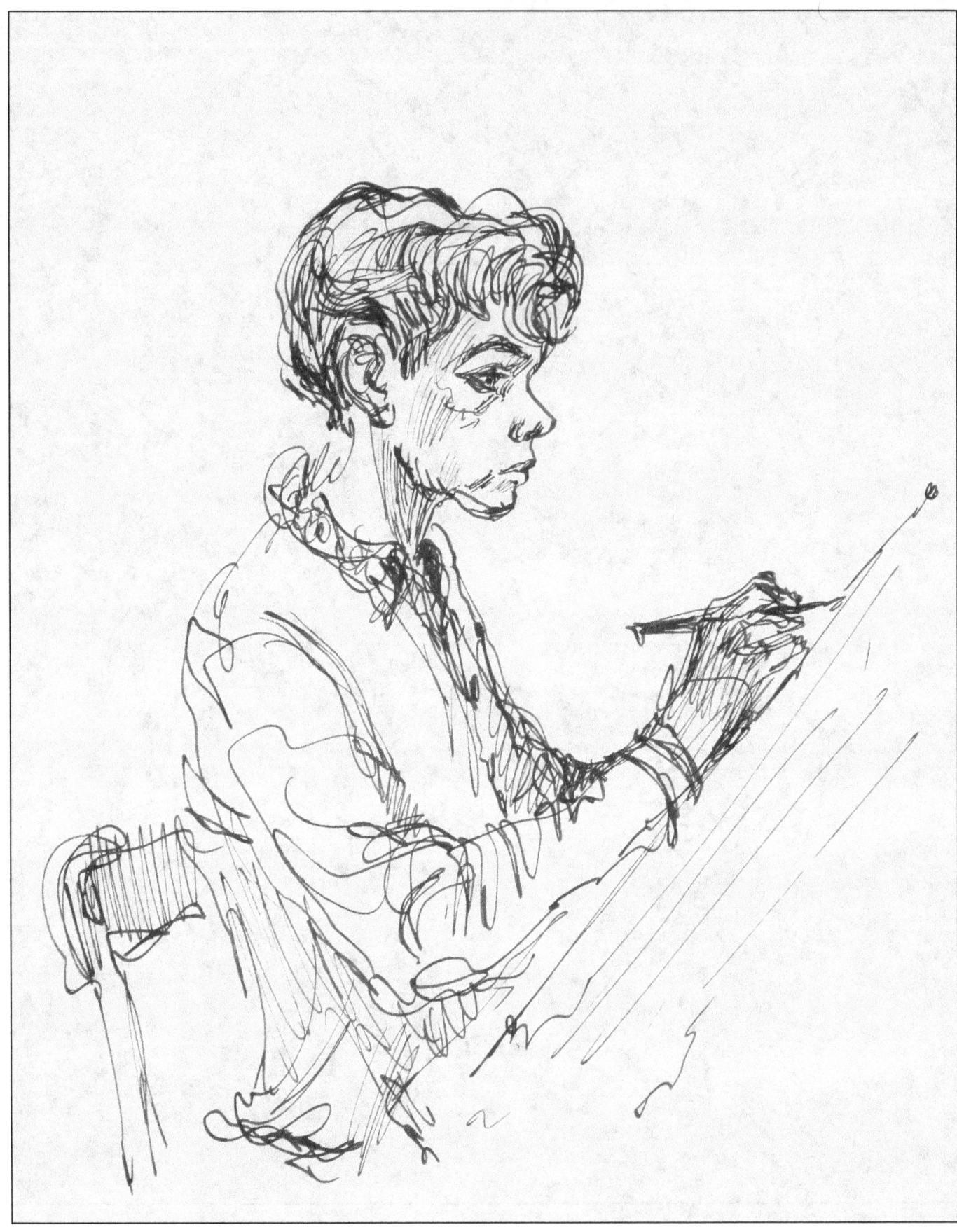

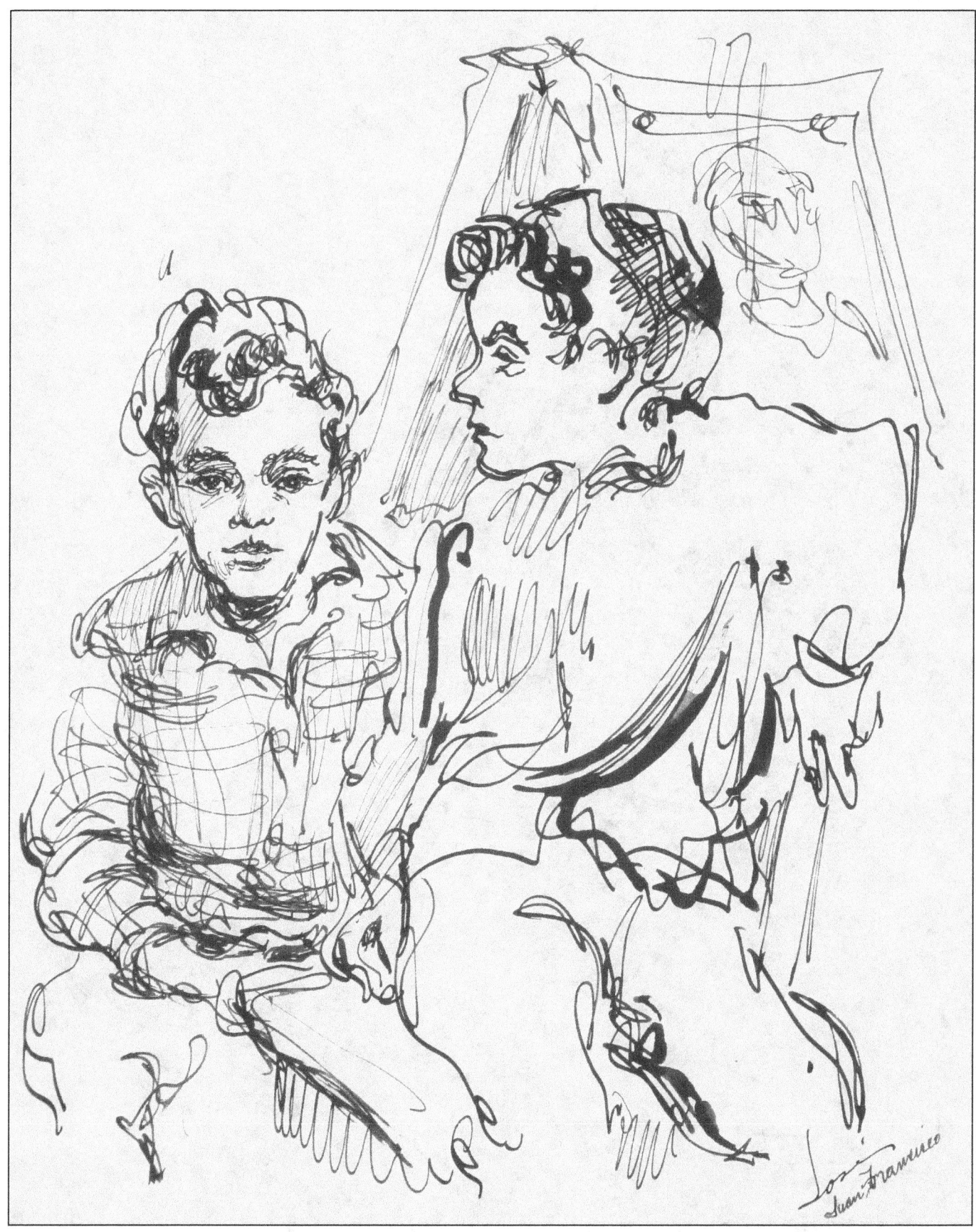

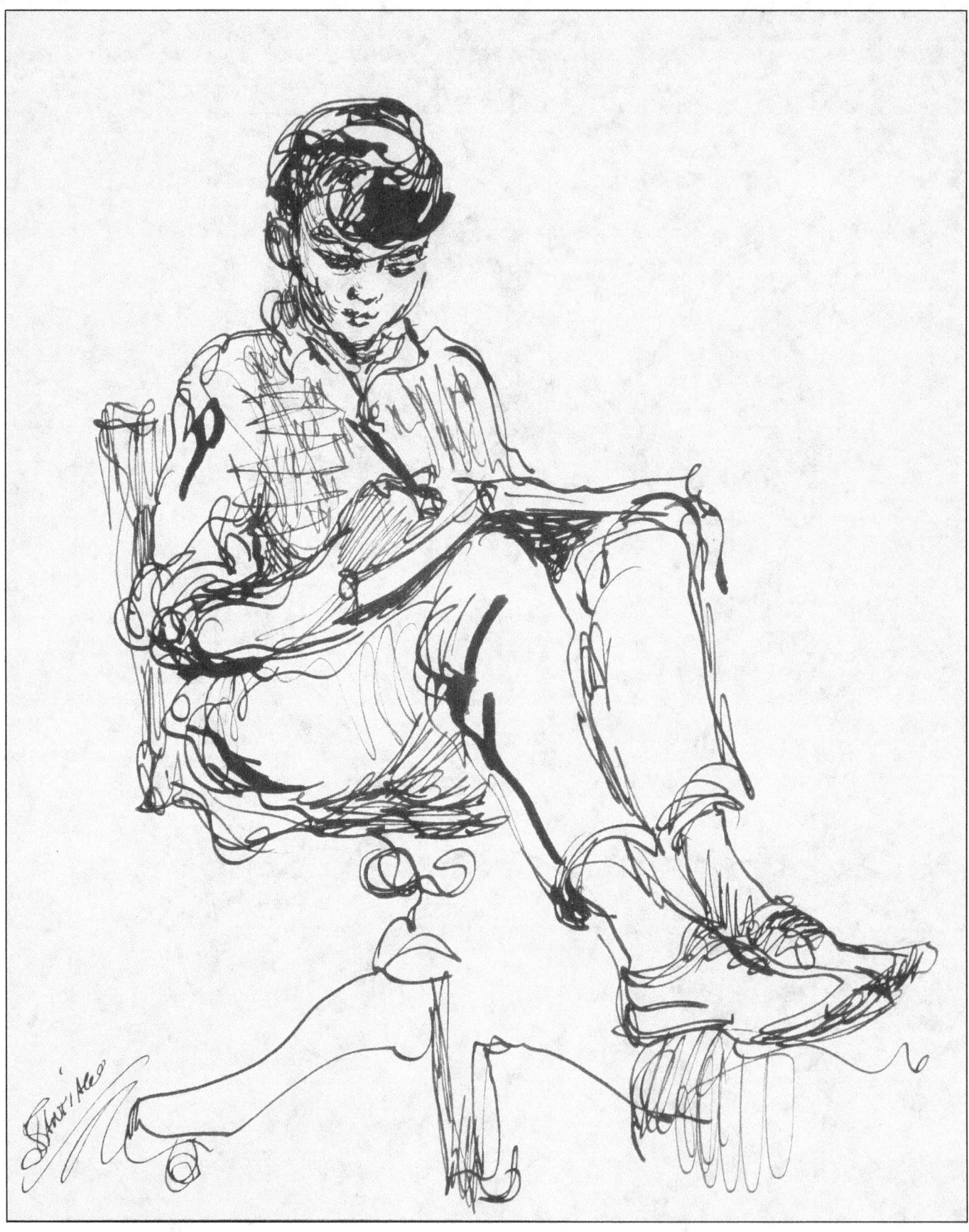

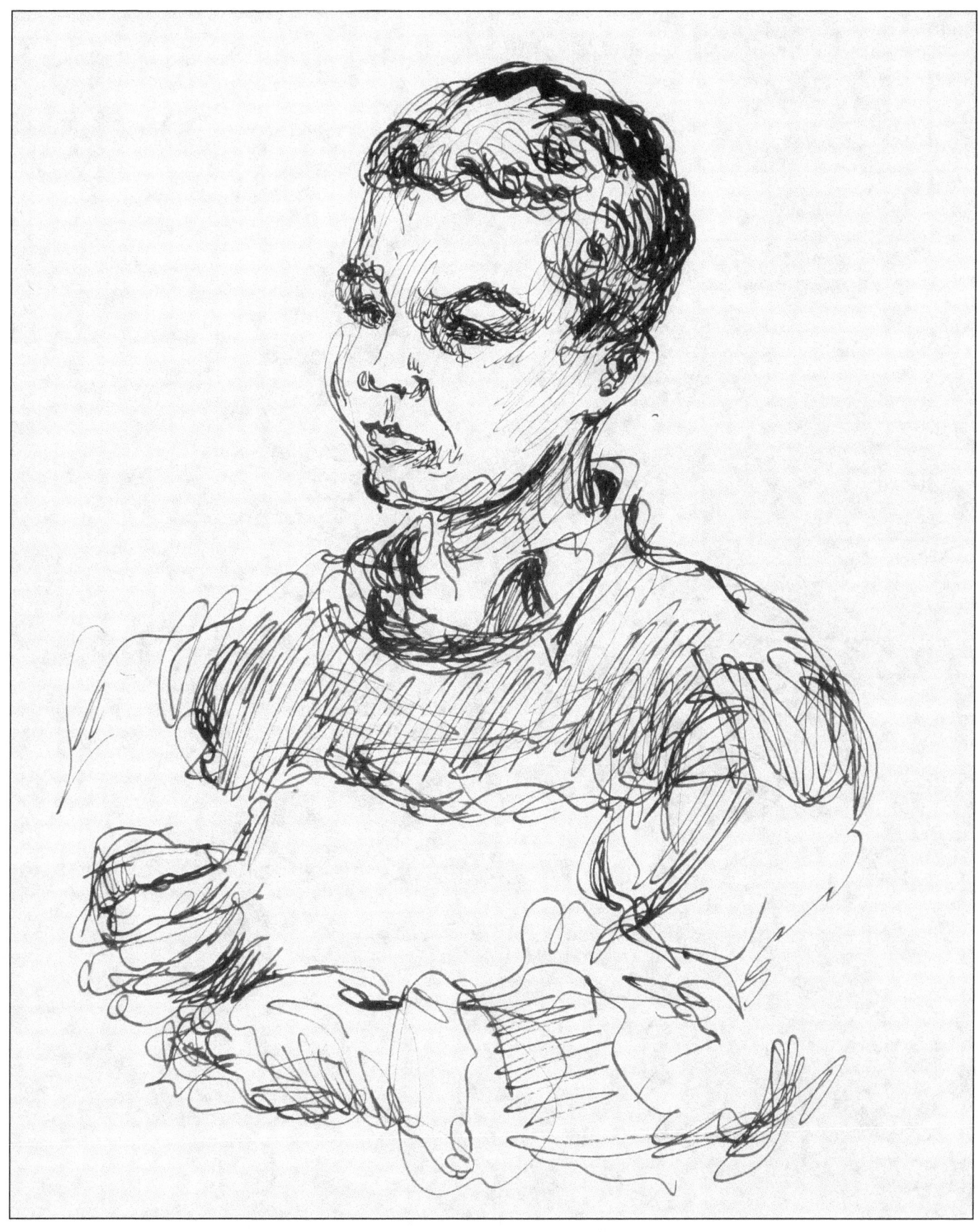

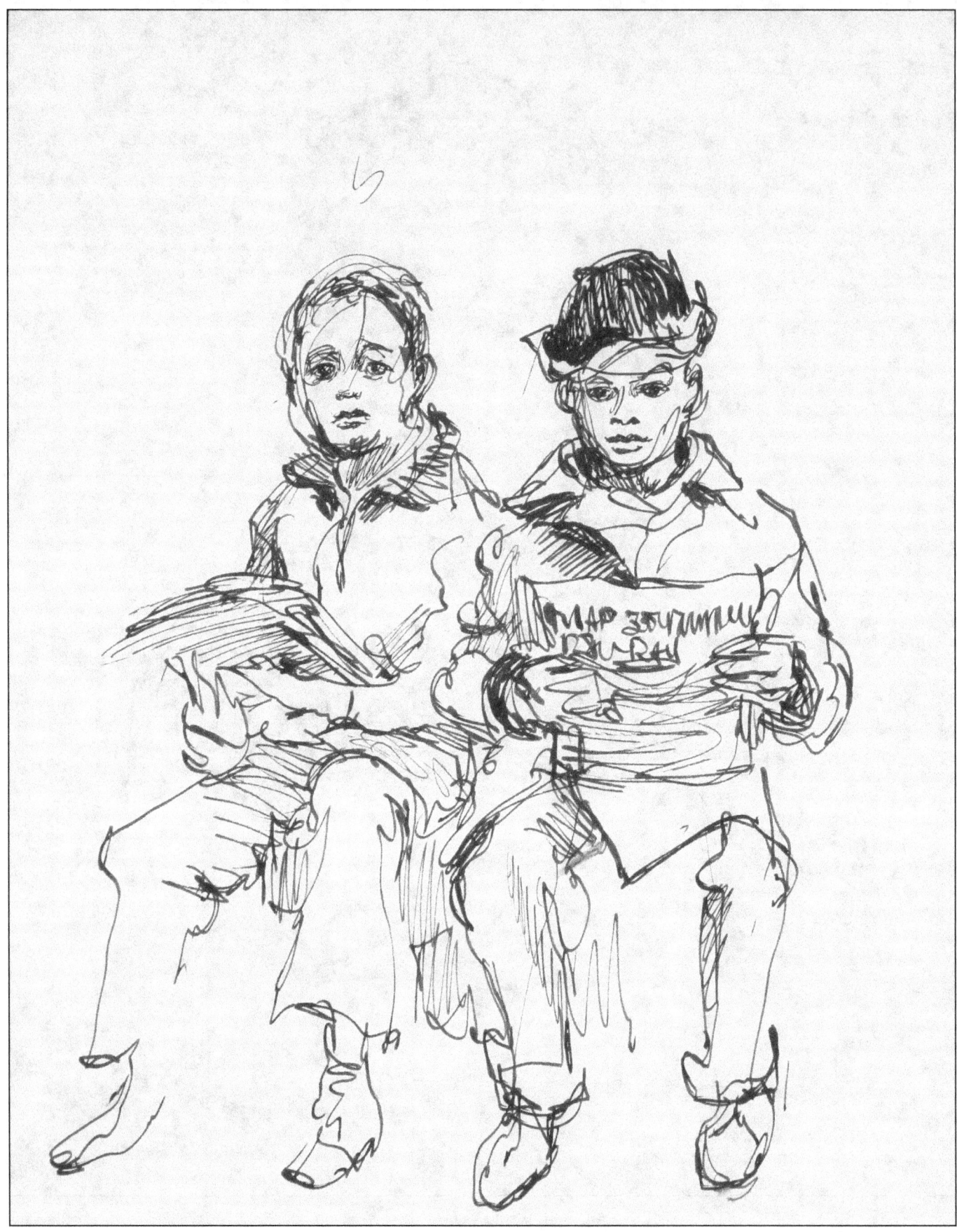

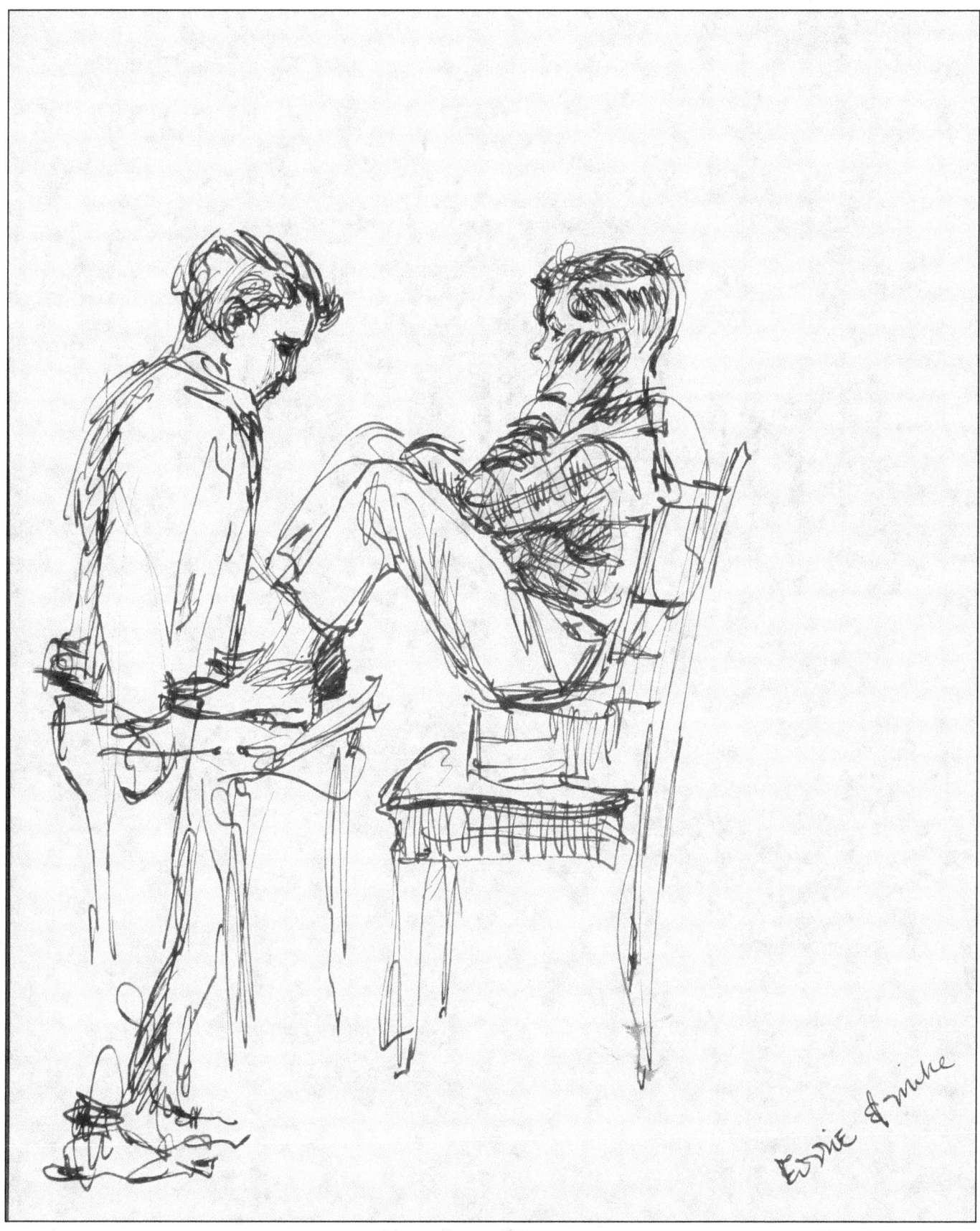

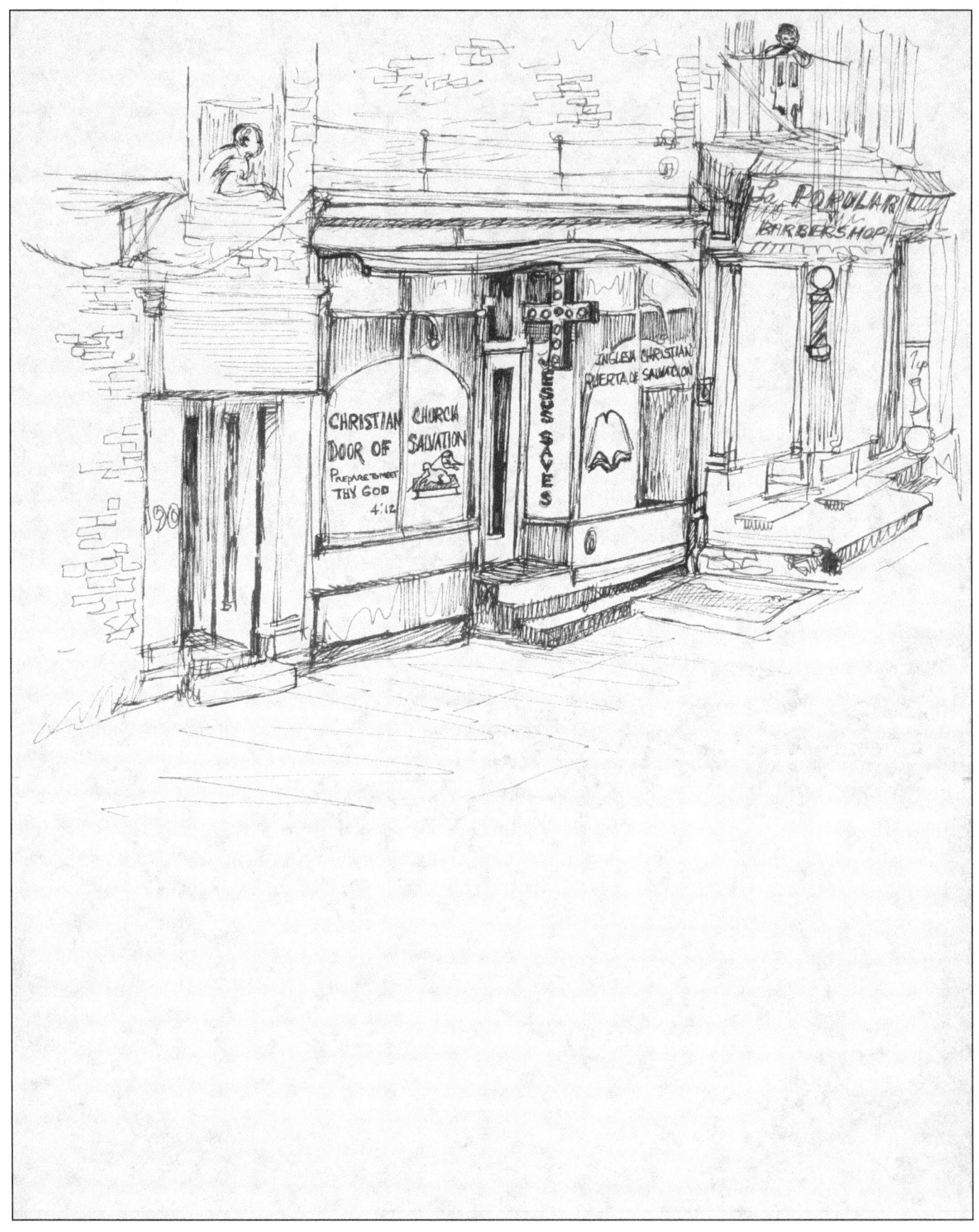

# ABOUT THE AUTHOR

## JOSEPH WOOD PAPIN

### 1931-1992

Joseph Papin specialized in reportorial art - on-the-scene drawing - the artist as reporter. He illustrated Washington, covering legislation in the House and Senate, and all the activities of a Presidential inauguration. He covered most of the major U.S. trials for over two decades, the Watergate hearings, the United Nations, and a spectrum of events, large and small.

A freelance artist since 1957, Joe Papin's work appeared in USIA's *American Illustrated, Harper's, Newsweek, Business Week, The Reporter, American Heritage, Forbes, Playboy, The National Review* and a host of specialty magazines. Among newspapers he contributed to *The Herald Tribune, The New York Times*, and worked on staff at *The New York Daily News*, where his reportorial drawings depicted the major trials for over twenty years. He illustrated over forty-five adult and children's books, lectured at colleges and for professional societies, gave many demonstrations, and had numerous shows, including one that traveled the U.S. for over two years. He was the recipient of seven Page One Awards for Graphic Excellence in Journalism and the New York Press Club Art Award for Reportorial Art/Courtrooms: Outstanding Artist of the Year.

Joe Papin started as an artist working his way through Ohio State University; made training films for the Army Signal Corps; and represented himself as a freelance artist for thirteen years, "thereby receiving another sort of education and, just frequently enough, some nice commissions, books to illustrate, and challenges to grow on." In 1969, he was invited to join the Daily News and worked to develop, enlarge, and reassert the place of the documentary artist in news coverage. For example, along with over 125 journalists and cameramen (still and T.V.), he covered the Hearst trial in San Francisco. He filed more than 400 drawings with the News, 3,000 miles away, over a portable telecopier (maximum sixe, 8" x 10"), the majority of which were used in the paper.

Joe Papin's work encompassed the areas usually covered by photographers. He drew U.N. scenes, military and international subjects, concerts, parades, horse races, hospital emergency rooms and thousands of street scenes. His first love and compelling interest was drawing on-the-scene, where history happens.

His career was cut short in 1992 due to his untimely death from melanoma. In 2015, his wife, Jane Papin, donated the extensive collection of his courtroom art work to the Library of Congress, over 4,750 drawings, as the Library of Congress has been developing a focus and interest in courtroom art. The contribution to the Library of Congress was made so that subsequent generations would have access to his work and the events that he documented.

Joe Papin drew voraciously, sketched everywhere he went, and shared his love of reportorial art with everyone he met. At the beginning of his career as a free-lance artist in the later half of the 1950s, he wandered the Bowery, drawing and recording the stories of the street people he met there. He also worked with the East Harlem Protestant Parish, illustrating their work with the community and with the gangs in the area, and he taught art classes to the youth. Joseph Papin mentored and encouraged young artists, emphasizing the importance of drawing from life to record history at the moment it happens.

www.ingramcontent.com/pod-product-compliance
Lightning Source LLC
Chambersburg PA
CBHW081213180526
45170CB00006B/2324